RAYLEIGH
THROUGH TIME
Mike & Sharon Davies

AMBERLEY PUBLISHING

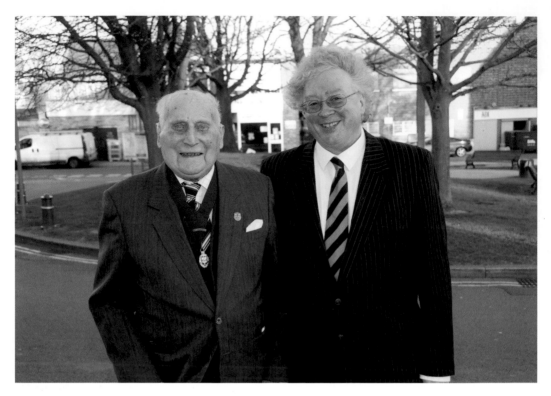

This book is dedicated to Ernie 'MR RAYLEIGH' Lane, the eminent Rayleigh historian of the twentieth century and the founder and creator of all we do at Rayleigh Through The Looking Glass. He is a very dear friend, who even at the age of ninety-four gives regular advice, guidance and support. Long may it continue.

Mike Davies
October 2012

First published 2013

Amberley Publishing
The Hill, Stroud
Gloucestershire, GL5 4EP

www.amberley-books.com

Copyright © Mike & Sharon Davies, 2013

The right of Mike & Sharon Davies
to be identified as the Author of this work
has been asserted in accordance with the
Copyrights, Designs and Patents Act 1988.

ISBN 978 1 4456 1330 7

British Library Cataloguing in Publication Data.
A catalogue record for this book is available from
the British Library.

Typeset in 9.5pt on 12pt Celeste.
Typesetting by Amberley Publishing.
Printed in the UK.

Introduction

Rayleigh derives its name from the Saxon words *raege* (a wild she goat or roe deer) and *leah* (a clearing). Although its origins are in prehistoric times, Rayleigh's prominence is due to its elevation as part of the ridge of hills spreading from South Benfleet to Hockley. When William the Conqueror invaded England in 1066, one of his first acts was to order the building of a network of castles. Robert Fitzwymarc, who held the 'Honor of Rayleigh' before the invasion, was one of the few allowed to retain land, and he built his castle in Clavering in the north of Essex. It was his son who built Rayleigh's motte and bailey castle – in the words of the *Domesday Survey*, 'in this manor Sweyne built his castle'. It is the only Essex castle mentioned in *Domesday*. The population of Rayleigh at the time was in the region of fifty people, and the village had a vineyard.

Although Rayleigh had been an area of religious devotion since Saxon times, its distinctive parish church at the top of the High Street dates mainly from the Perpendicular period (fourteenth to sixteenth centuries). In 1555, two Protestant martyrs were burnt at the stake for refusing to deny their faith, and a memorial was erected to their memory in 1908 at the top of Crown Hill. In the nineteenth and early twentieth centuries, a branch of the Peculiar People religious sect was prominent in the town.

Rayleigh market has one of the earliest Royal Charters in Essex, dating from 1181, and the Charter for the Trinity Fair, which was the agricultural workers' and farmers' annual holiday, and their meeting to buy and sell animals and related items, dates to 1227.

Rayleigh was an important town on the Rochford Hundred Adjoining Roads Division of the Essex Turnpike Trust, set up in 1746. The 'King's Highway' from Wickford passed along the London Road, past the site of what is now the Carpenter's Arms public house. At the top of London Hill the highway branched into two: one route to Hockley and Rochford and the other to Hadleigh and Leigh. Several milestones remain by the side of the road from Rayleigh to Rochford as a reminder of those days. Many inns and smithies supplied the needs of both travellers and horses.

Rayleigh was the original home of the Whispering Court, one of the earliest Manorial Courts in the county, dating back over 400 years. It was located in Kingley Wood, which in 1925 was cut in two by the arrival of the new A127 close to Rayleigh Weir. The Lord of the Manor, returning home late one night, heard several of his tenants plotting against him in whispers. He made

them swear allegiance to him at a special court, which was held annually at dead of night. The court later moved to Rochford.

At 240 feet above sea level, the town and its immediate vicinity were a prime location for windmills. The first documented windmill in Rayleigh dates from 1300 when King Edward I instructed the Prior of Prittlewell to erect a mill in Rayleigh. It was probably a wooden mill near the mount and castle. Wooden mills were liable to fire, and many would have been rebuilt on the site. Records show details of five mills in Rayleigh, but there may have been several more. One of the earliest was a watermill in the grounds of the White House, once a substantial farm covering hundreds of acres by the Eastwood Road and part of the Royal Hunting Forest. It was believed to be one of the areas used by Henry VIII and Anne Boleyn when courting. There may also have been a watermill near the site of Rayleigh Castle.

The first detailed map of Essex (1777) shows a windmill in the Hockley Road – Ruffles, demolished in the nineteenth century – and one opposite the Methodist church in what was called Mill Lane, now Eastwood Road. In 1793, a second mill was erected close by and the name of the road was changed to Two Mill Lane. Both these mills were demolished in the 1880s. There was conjecture for many years as to the date that Rayleigh's remaining mill was built. Benton states that it was built in 1798 by the licensee of the Lion Public House, but later research suggests the land was purchased in 1808 by a Mr Thomas Higgs, together with an adjoining brickfield, and the mill was completed the following year.

The advent of the railway in 1889 turned Rayleigh from a tranquil nineteenth-century village with a population of around 1,500 to the bustling, vibrant town it is today with a population of roughly 35,000.

The first arterial road in the country specifically built for motor vehicles was opened in 1925 (now the A127) and passed the edge of Rayleigh. As a result, some of the large farms and manor houses were to become the housing estates that are familiar to us today. At this time locals and visitors were entertained in the Clissold Hall by the Rayleigh Minstrels or saw early black-and-white silent films at the Cosy Talkie Theatre. Rayleigh also had its own brewery and several brickfields. Many will recall the Speedway Stadium near Rayleigh Weir, home of the Rayleigh Rockets from 1948 to 1973. In addition greyhound racing, stock car racing, wrestling and other sports took place here.

The castle may have been demolished in the fourteenth century, but the Mount where it stood and the Tower Windmill, which celebrated its 200th anniversary in 2009, can still be enjoyed today. Many of Rayleigh's well-known landmarks are commemorated by the twenty-one heritage plaques giving details about the origins of the sites. Rayleigh Town Council has a heritage brochure and map showing their locations and origins. All of these are well worth a visit next time you are in Rayleigh.

Welcome to Rayleigh

From the 1960s and for over twenty-five years, the first sight of Rayleigh that greeted motorists driving from the Weir into town was this wonderful floral display at the junction of the High Road with Orchard Avenue, seen in the lower photograph. The flower bed was maintained by Ernie Lane, also seen in this photograph, and a group of his friends. Rayleigh Town Council have recently moved one of the 'Welcome to Rayleigh' signs that appear at the four main approaches to town and reintroduced Ernie's flower bed, as seen in the top photograph. The floral displays around town command high praise from the Anglia in Bloom judges every year.

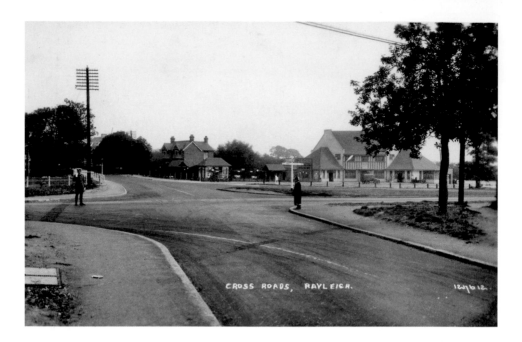

CROSS ROADS, RAYLEIGH.

Rayleigh Weir I
The first road in this country to be built specifically for motorised vehicles, the London A127 arterial road was officially opened by Prince Henry of Gloucester on 25 March 1925. Two cottages once stood in the middle of this site but were demolished to create this junction when the road was built. Note the AA man waiting to salute his members. Also note the fence behind, erected to help protect motorists from the pond of the Weir Farm House. Originally a single-track road with cycle path, it later became a dual carriageway, while the roundabout was built shortly before the Second World War.

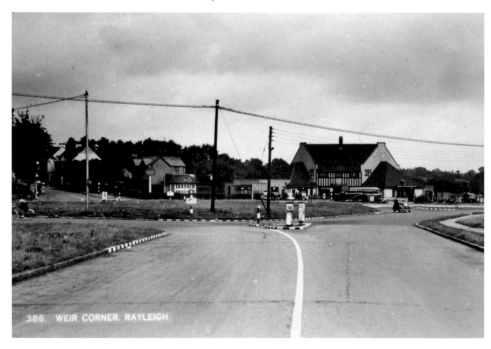

386. WEIR CORNER. RAYLEIGH

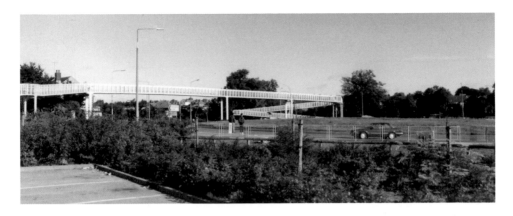

Rayleigh Weir II

The volume of traffic increased in line not only with the local population but also with increasing car ownership and numbers of coach parties on their way to the delights of Southend-on-Sea. With the shopping area opposite the Weir Hotel even pedestrians were considered, as this mid-1980s picture of the walkway shows. However, traffic volumes were such that first a flyover and then an underpass were considered. On 19 December 1991, local MPs Sir Bernard Braine and Dr Michael Clark officially opened the underpass and traffic started flowing at 3.00 p.m.

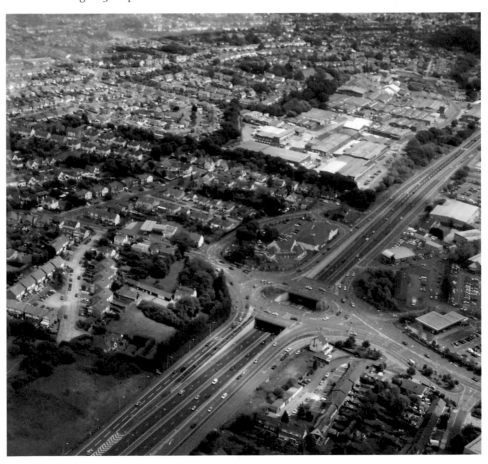

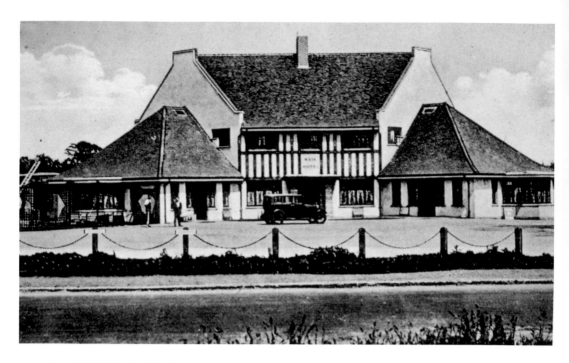

Rayleigh Weir Public House

The Weir Hotel opened shortly after the arterial road, having taken over the licence of the closing Elephant & Castle public house, which stood at the junction of the High Street and Castle Road. The Weir was a regular stop for visitors on their way to Southend and, from 1948, for those about to enjoy the various entertainments at the Rayleigh Speedway Stadium opposite, which included speedway and greyhound racing. The entrance to the pub can now been found at the rear, as shown in the lower photograph.

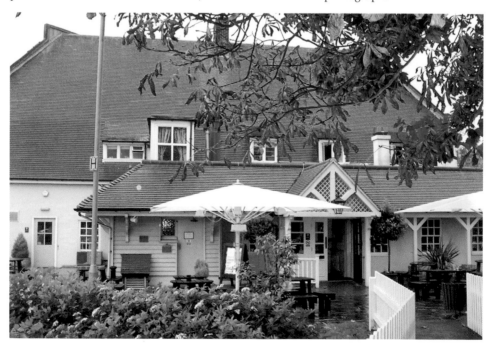

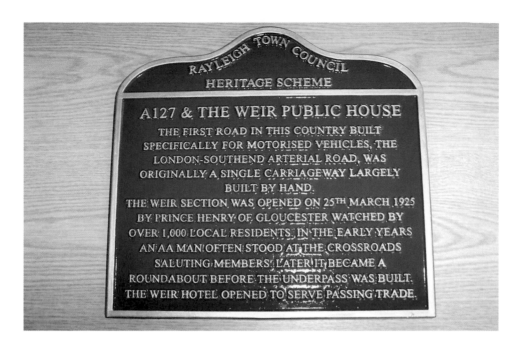

RAYLEIGH TOWN COUNCIL
HERITAGE SCHEME

A127 & THE WEIR PUBLIC HOUSE
THE FIRST ROAD IN THIS COUNTRY BUILT
SPECIFICALLY FOR MOTORISED VEHICLES, THE
LONDON-SOUTHEND ARTERIAL ROAD, WAS
ORIGINALLY A SINGLE CARRIAGEWAY LARGELY
BUILT BY HAND.
THE WEIR SECTION WAS OPENED ON 25TH MARCH 1925
BY PRINCE HENRY OF GLOUCESTER WATCHED BY
OVER 1,000 LOCAL RESIDENTS. IN THE EARLY YEARS
AN AA MAN OFTEN STOOD AT THE CROSSROADS
SALUTING MEMBERS. LATER IT BECAME A
ROUNDABOUT BEFORE THE UNDERPASS WAS BUILT.
THE WEIR HOTEL OPENED TO SERVE PASSING TRADE.

Heritage Plaque Scheme

By the entrance to the pub can be found one of Rayleigh Town Council's heritage plaques, whose historical content came originally from Ernie Lane and now from Rayleigh Through The Looking Glass. The Town Council have an ongoing scheme of erecting plaques on suitable buildings. Details can be found not only on the council's website but also on the double-sided heritage noticeboard in the High Street opposite the Millennium Clock, together with additional full details of all the many heritage sites in and around town.

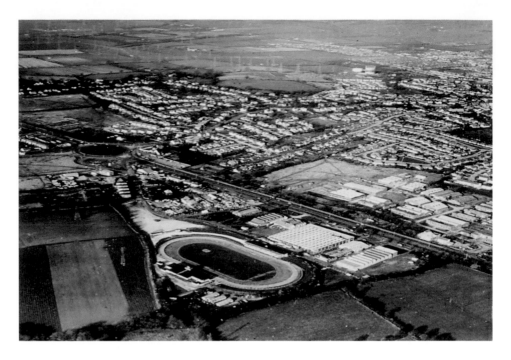

Rayleigh Stadium

In 1948 a stadium, seen here from the air, was opened close to the Weir. It was home not only to the Rayleigh Rockets speedway team but also to greyhound racing, stock car and midget car racing, harness horse racing, open-air wrestling, firework displays and much more. Sadly, the speedway racing ended in 1973 and the last greyhound meeting took place in 1974. The stadium was demolished to make way for a retail outlet. Stadium Way, as seen below, commemorates the way to the venue.

Rayleigh Stadium

Home to the Rayleigh Rockets, attendances were regularly in excess of 10,000. Special trains and buses were laid on from as far away as London. Many locals still remember the noise of the bikes speeding around the track, which could be heard from their back gardens on Saturday evenings. The upper photograph shows an early programme. The lower picture, taken in the early 1970s, shows many well-known faces, including owner/promoter Len Silver, standing far right, and next to him Terry Stone, who still arranges reunions of riders and fans to this day.

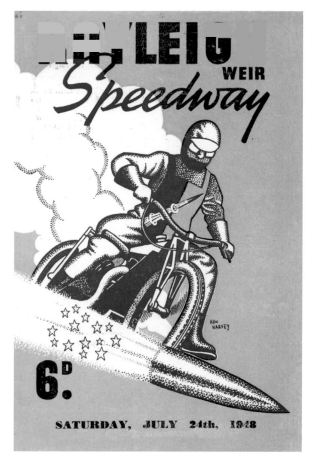

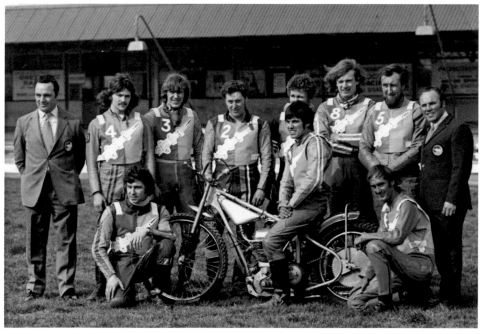

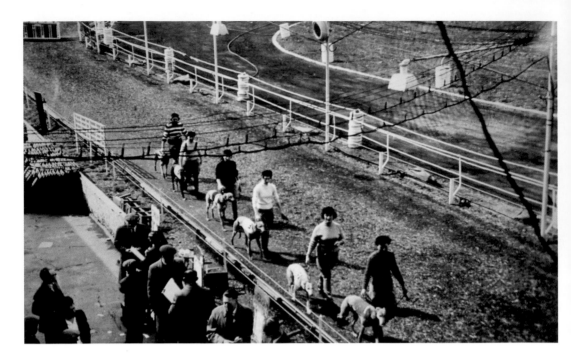

Rayleigh Stadium

Greyhound racing was one of the other popular sports that took place at the stadium. In this picture note the speedway track inside where the greyhounds are parading. Saturday night racing would sometimes not start until 10.00 p.m., with the last race staring at 11.45 p.m., to allow owners, trainers and spectators to first watch the greyhounds at the track in Southend before travelling to Rayleigh. Sometimes speedway meetings would take place earlier. Motorsport was also very popular, including Stock cars, as seen below, hot rods, midget cars and death destruction derbies.

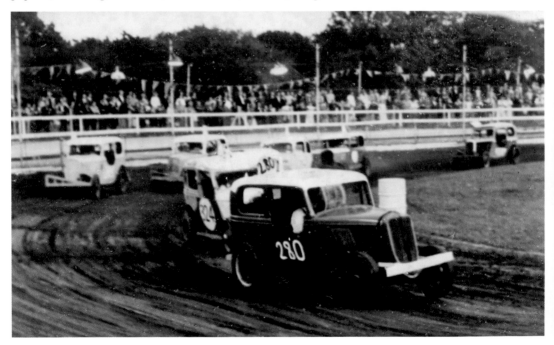

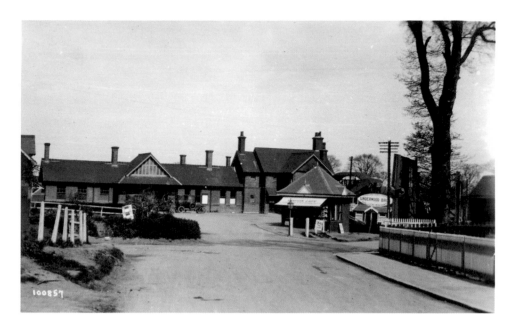

Railway Station

Rayleigh was a quiet, tranquil, mainly agricultural backwater with a population of 1,300 in 1881, but all that was to change when on 1 October 1889 the railway, in the form of the Great Eastern Railway from Liverpool Street to Southend Victoria, arrived. The stationmaster's house was the large building to the right of the main entrance, seen here in 1920, while the staff cottages were situated on the left where the taxi rank can be found today.

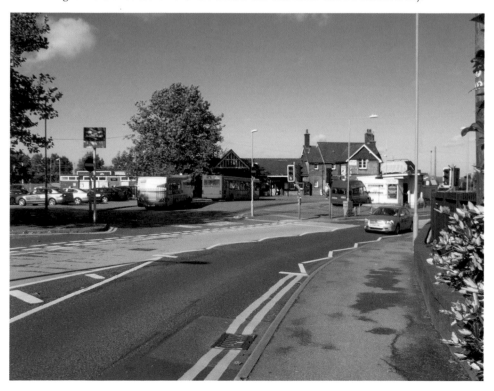

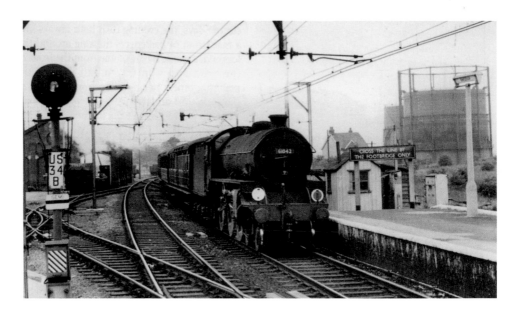

Railway Station

We believe that this picture, with a Thompson B1 4-6-0 no. 61042, may show the last day of the steam trains through Rayleigh, on 30 December 1956. The electric service commenced the next day. Note the overhead electric pylons ready for the new service as well as the two gasometers, now long gone. In 1900 there were 107 season ticket holders at Rayleigh; by 1960 this had increased to 20,000.

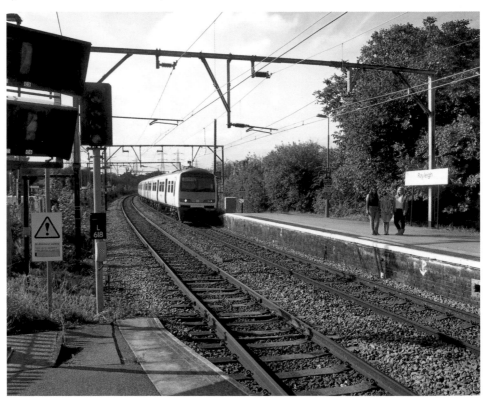

Railway Station

This picture shows the first view that passengers would see on leaving the main entrance. The gates to the station staff houses can be seen on the right of this picture. The station café is fondly remembered by many for a quick breakfast before getting on the train to work. In October 1996 a bus accidentally ran into it. Thankfully only one or two minor injuries were sustained, but sadly the café had to be demolished. Note the television crews in the foreground.

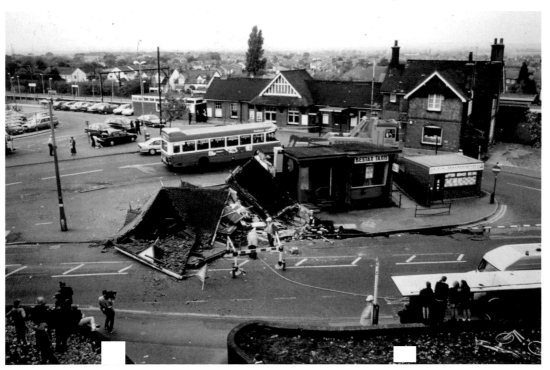

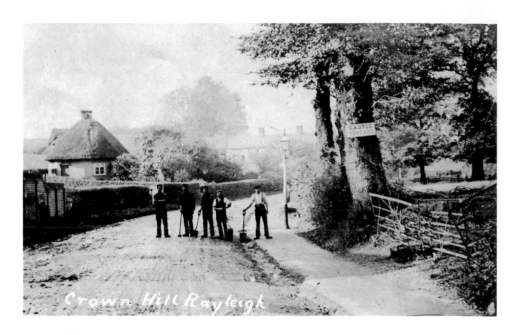

Crown Hill

How many workmen did it take to sweep the roads in Rayleigh in the mid-1920s? Well, this photograph gives the answer. Named Crown Lane until the early 1920s, Crown Hill was originally just a footpath, London Hill being the main road into town. Here we see our first glimpse of the Dutch Cottage. Also note the road name for Castle Terrace nailed to the tree by the five-bar gate. The remnants of the tree can still be seen today if you look carefully between the lamppost and telegraph pole in the lower picture.

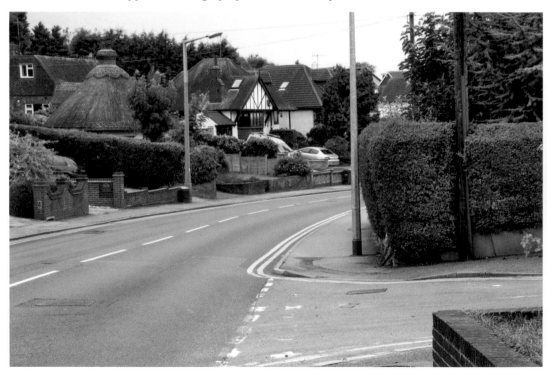

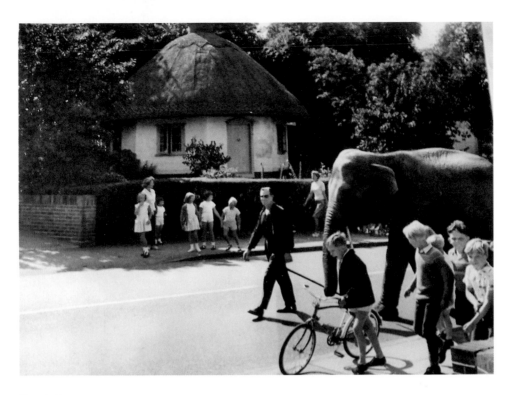

Dutch Cottage

The circus comes to town in this photograph from 1963. An elephant is seen here passing the Dutch cottage on its way around town. For many years the circus was held in a field by the Travellers Joy, by the junction of Rawreth Lane and the Hullbridge Road, and in Webster's Meadow (now King George's Playing Field). The Dutch Cottage is probably the most unusual and cheapest council house in the country. It is open to visitors by appointment with Rochford District Council. The lower picture, taken in 2010, shows a lovely wintry scene.

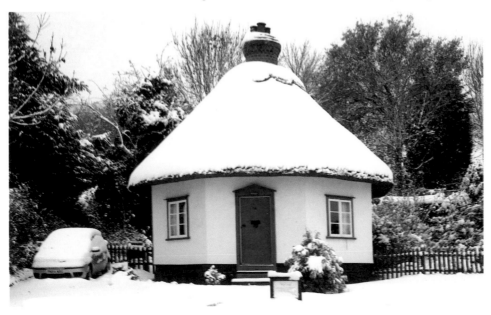

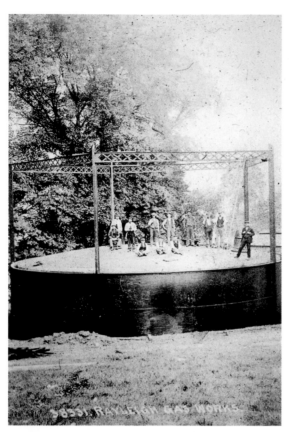

Rayleigh Gasworks

The gasworks was located further up Crown Hill on the way to the High Street. Gas was the first utility to arrive in the town in 1859. In this late 1920s image, note the men standing on top of the gasometer (now the site of the Jehovah's Witness hall), the land for which was dug as part of a brickfield previously on this site. The house at the front showing 'Rayleigh Gas Company' is now a residential property.

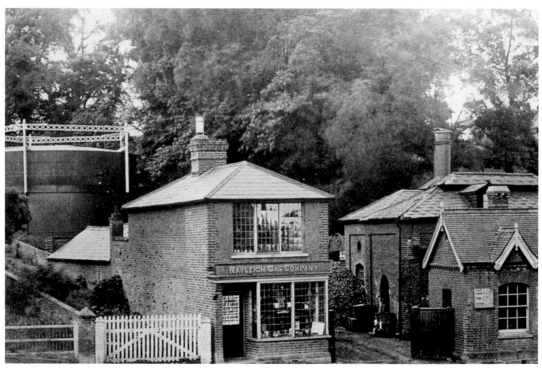

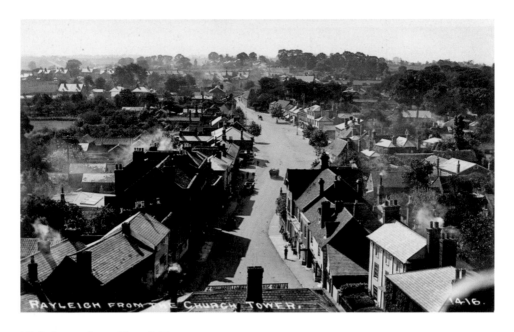

High Street from Church Tower

A panoramic view from the top of our parish church, Holy Trinity, along the wide expanse of our historic High Street, around 1910. The Half Moon pub (front left), originally called the Greyhound, is still recognisable, and the residential property seen by the tree at the front on the right was once home to Mr Toes the dentist. The church tower is open for viewing on the first bank holiday in May each year and on a fine, clear day there are views over the Crouch Valley, Southend and the mouth of the Thames, and Canary Wharf in London's Docklands.

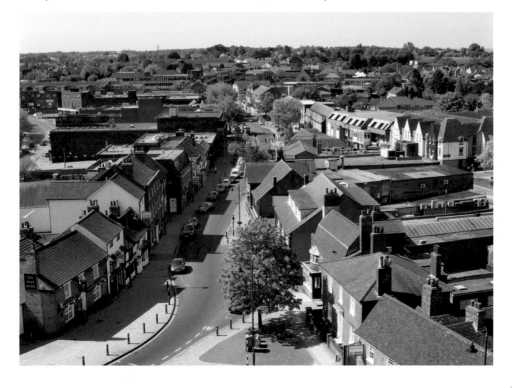

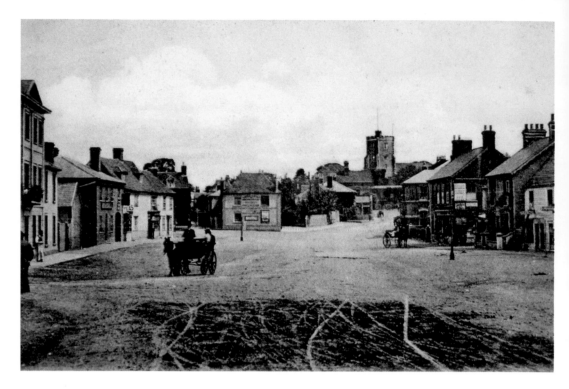

High Street Towards Church

An early view of the High Street (*c.* 1880) with Holy Trinity church tower as the focal point. It is a popular vista, used over the years by many for postcards, photographs, and paintings. The wide expanse of the High Street is that of a typical Saxon town, centering on the most important building, the church, and ideal for the regular markets and fairs. The trees seen in the lower photograph were planted in the early 1900s by one of the town's great benefactors, Edward Francis, who lived in what is now Lloyds Bank.

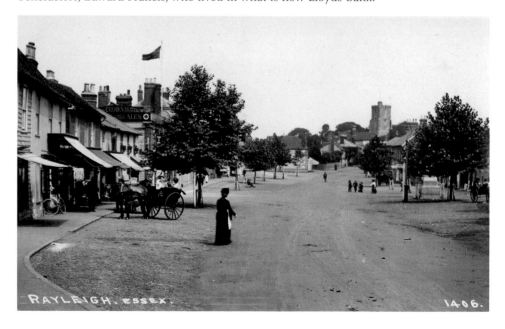

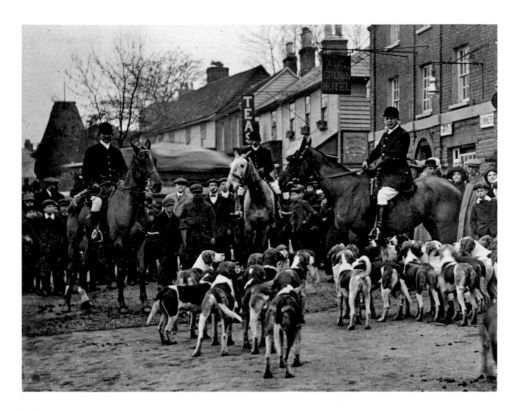

The Hunt

The Local and Essex Hunt met regularly outside the Crown Hotel until the outbreak of the Second World War in 1939. One of its leading lights in the early twentieth century was the formidable Miss Augusta Tawke who lived with her mother at Bullwood Hall along the Hockley Road. Only the local gentry and prominent businessmen were members of the Hunt, but this did not stop many locals from watching the event, as can be seen in the top picture. The oast house in the background was that of Luker's Brewery which was demolished in 1922. Compare the lower current view of the same site.

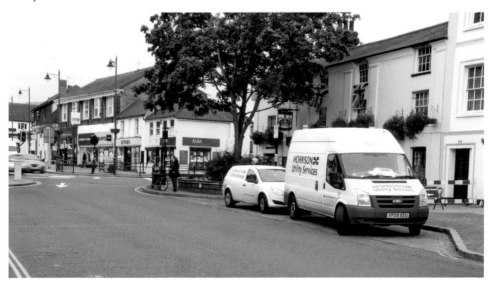

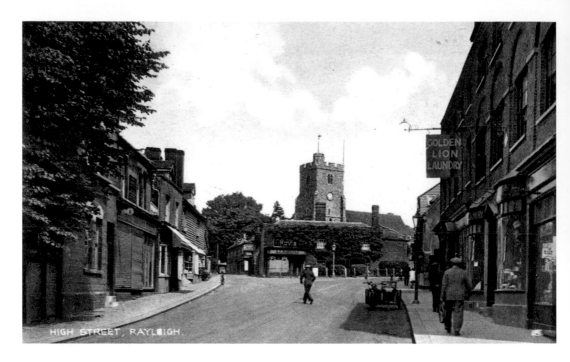

Wisteria House

This distinctive Wisteria House in front of Holy Trinity was at one time a corn exchange and later an early telephone exchange. In 1908 the rector, Revd Girdlestone Fryer, wrote in his book *Rayleigh in Past Days* that the view of his church was spoiled by these buildings and hoped that one day they would be demolished. In 1932 his wish came true, and the contrast between these pictures is self-evident.

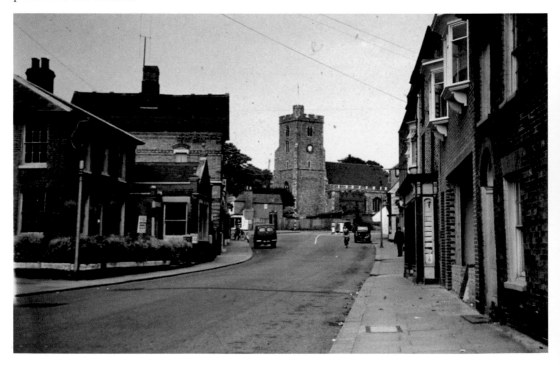

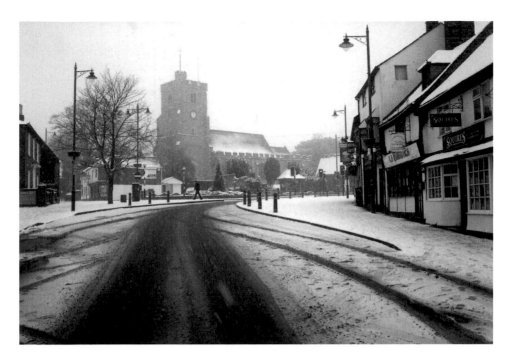

High Street Towards Holy Trinity

A modern winter view. On the right is Squires Coffee shop, one of several seventeenth-century buildings remaining in the High Street. A variety of traders have been on this site in the last century – cobbler's, pet shop, health food shop, to name but a few – but it has been firmly established as a quality coffee shop for many years. Holy Trinity flies the cross of St George in April 2011 in the lower photograph. It is scaffolded as part of Project 350, a project by the Friends of Holy Trinity to raise £350,000 for the repair of the tower and replacement of a number of stained-glass windows.

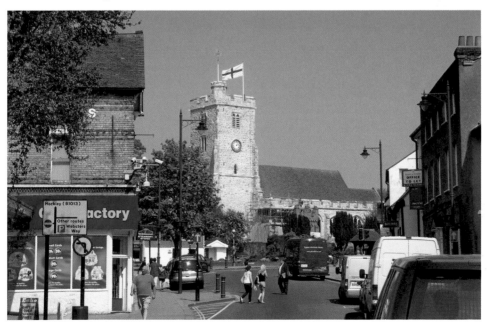

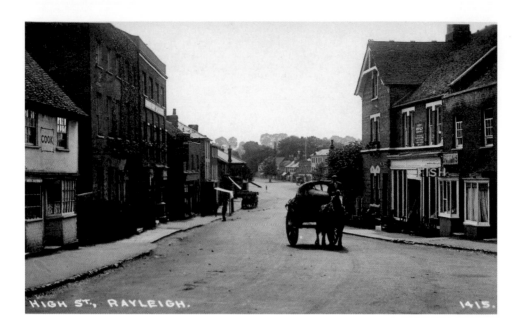

HIGH ST., RAYLEIGH. 1415.

High Street Looking South

We have now turned with our backs to the church. Note the significant change in mode and volume of transport over the last ninety years as evidenced by these two pictures. Most of the buildings are exactly as they were all those years ago.

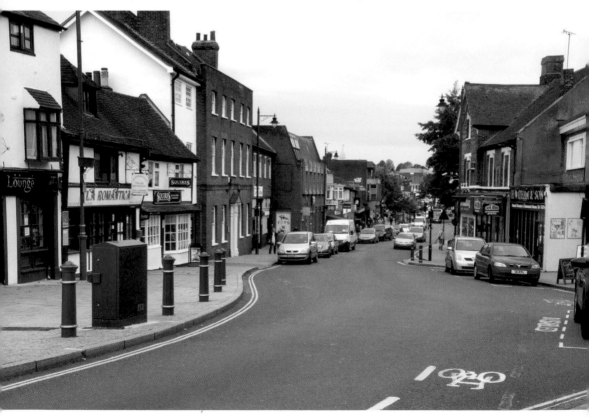

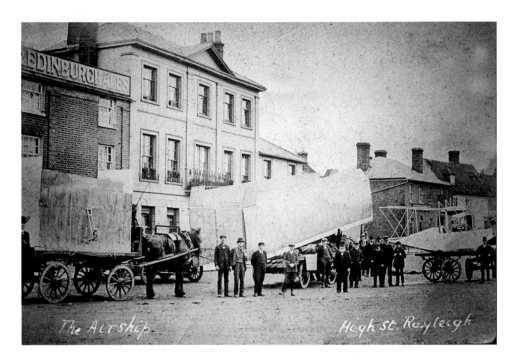

The Airship. High St. Rayleigh

Edward Francis House

We can only guess what this 'Airship' was doing passing through the High Street, possibly during or soon after the First World War. Was it in fact an aeroplane on its way to Rochford Aerodrome? Was it in a crash and on its way to be repaired? Readers of this book may have some suggestions. Edward Francis House is shown behind, now Lloyds Bank. Edward Francis was a great benefactor to Rayleigh and donated Rayleigh Mount to the National Trust in 1923.

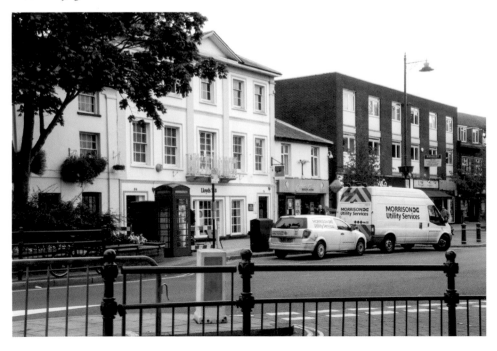

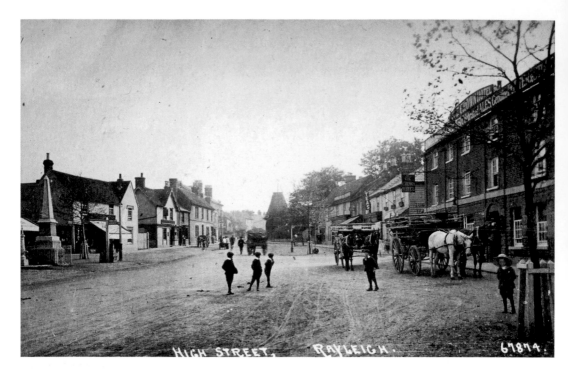

High Street Towards Crown

Look at the various horses and carts plying their trade in this next photograph. The Crown Hotel, one of the two coaching inns in town to service the mail coaches to and from London, was built around 1740 and does not have any foundations. Just as well; during the Second World War a bomb fell behind the building, but it merely shook up and down before settling again, and, unlike other local buildings, none of its windows were broken. The lower picture dates from around 1930 and shows a 1914 re-bodied Albion A12 bus with a 1925 Humber car facing the photographer.

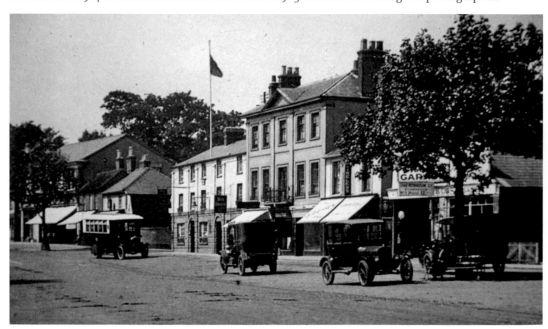

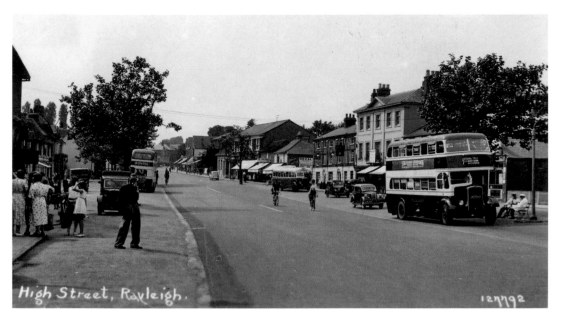

High Street, Rayleigh. 127792

High Street Towards Crown

The top picture, taken in the late 1940s, shows two Westcliffe-on-Sea service double-decker Bristol K5G motor buses, which had dark red and cream livery. The single-decker bus is a City Bus, which had a livery of brown and cream. The modern photograph shows just how the pavement has encroached on the road, now part of the town's one-way traffic system.

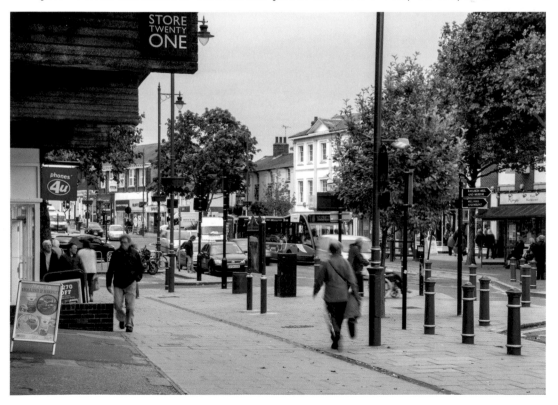

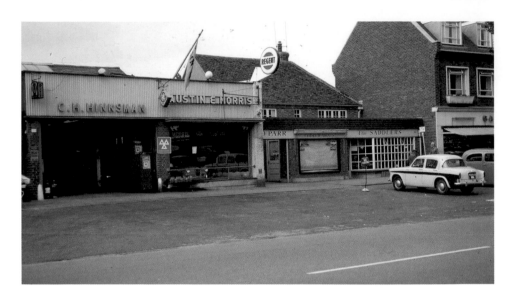

Hinksman's Garage

In the High Street, on the opposite side of the road to the upper picture, was Colvin &
Hinksman, perhaps the earliest motor garage in Rayleigh. As trade grew and the business
expanded, the two partners set out alone. This photograph shows Hinksman's Garage in
the 1960s, previously the Crown Garage. Also seen here are Parr's pork shop (it would
now be called a delicatessen) with the best pork pies in town and the Saddlers Restaurant,
named after a saddle and harness-makers shop owned by a Mr Clarry Stewart. The two
windows on the far right on the first floor are all that remain today.

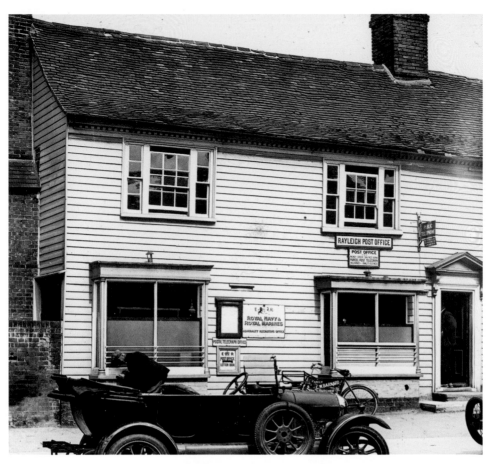

High Street Old Post Office

The top picture shows Rayleigh's second post office with a lovely 1925 Morris Cowley open-top tourer in front. In 1911, the daughter of the Methodist minister, Revd Nehemiah Curnock (internationally famous for deciphering John Wesley's coded diaries after 200 years), threw bricks through the windows in protest as part of the Suffragette movement. Her eyesight was certainly good enough not to require spectacles, as history relates that her aim was perfect.

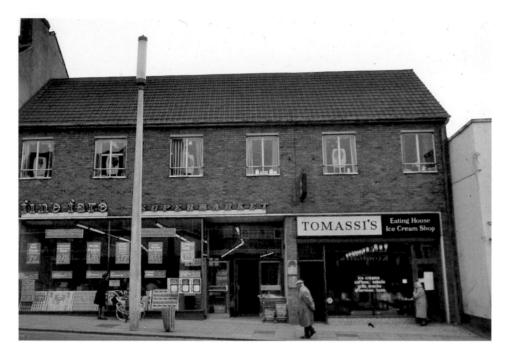

Fine Fare

Many locals recall an early 'supermarket' in the High Street by the name of Fine Fare, but many do not remember the well-known Southend firm of Tomassi, famous for its ice creams, possibly because it only traded for a short while in the 1960s. Below, well known to many youngsters, this property opened in 1976 as a nightclub called El-Pedrinos but it changed name to Crocs, due to the two live crocodiles in a cage, in 1979. It became the Pink Toothbrush in 1983, named after a song by Max Bygraves. When the crocodiles were donated to Colchester Zoo, it was found that they were in fact alligators!

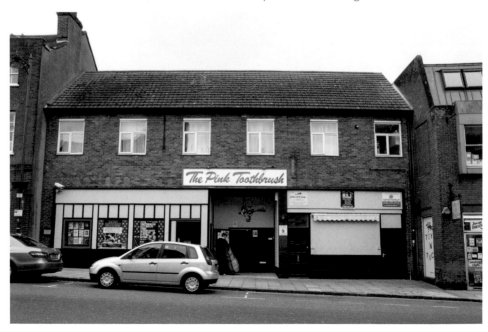

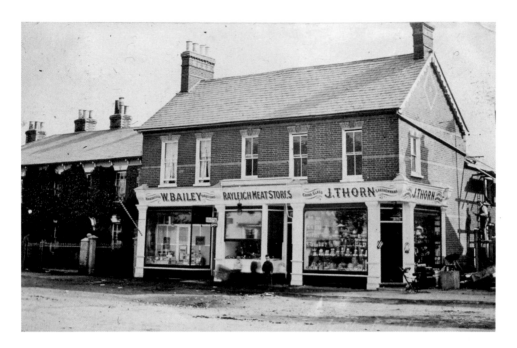

Thorns

Like many shopkeepers on high streets around the country, the owner lived 'above the shop'. This impressive group was known as Thorn's, whose hardware shop sold everything a lady would need for the home. Mr Thorn was a member of the Peculiar People religious group, and they held meetings on the first floor until their chapel was built in Bellingham Lane. Mr Boyes opened his first shop just along the alleyway, where the workmen on the scaffolding can be seen in the upper photograph in what is now Ernie Lane, next to Betfred, as seen in the lower photograph.

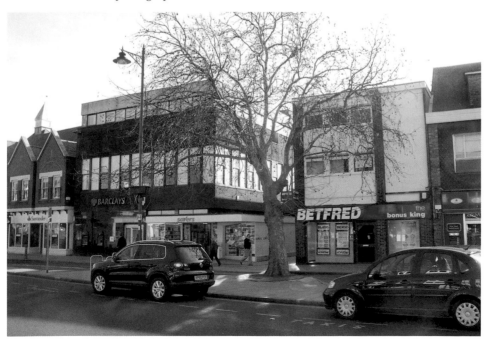

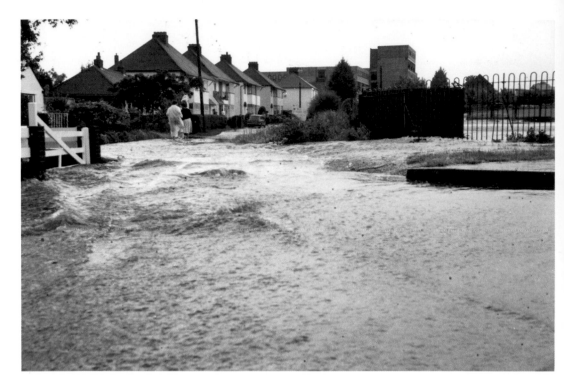

Road Flood

It never rains but it pours. The top picture, taken in 1989, shows the junction of Bull Lane with Stile Lane and King George's Playing Field. For many years the only drainage system in town was open drains with water flowing down Crown Lane and London Hill. The High Street regularly floods after downpours, melting snow and suchlike, as can be seen in the lower picture.

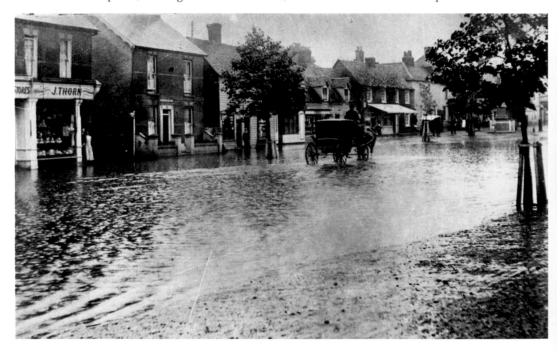

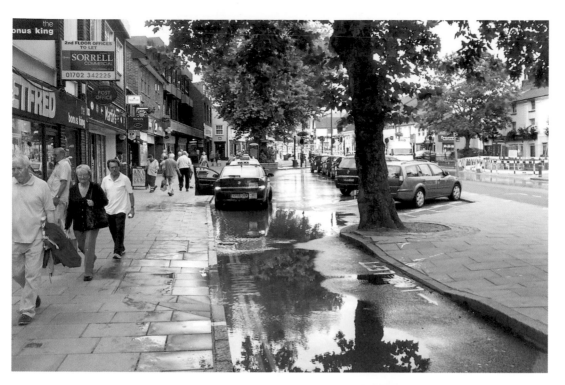

The Lagoon

The area where the taxis can be seen, now the location of the Wednesday market, is known locally as the Lagoon – most appropriate when the water main burst in 2010 and for a short while the area was renamed Little Venice. The lower picture shows the same area in 1953 when the coronation bunting was being erected. Can you spot the ancient milestone just by the estate office of Pinchbeck Chapman at the extreme left of the picture? The milestone was lost sometime in the 1960s, but it is hoped that one day a replacement will be installed on the same spot.

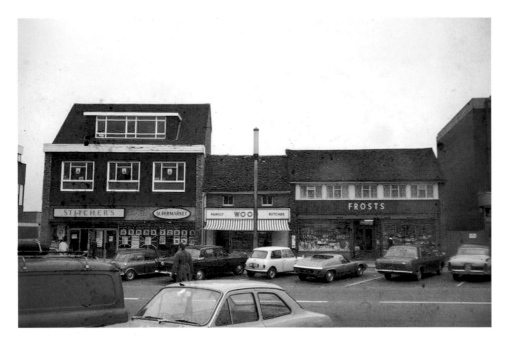

High Street New Post Office

Note the cars parked in the upper photograph, which dates it from before the various one-way systems of the early 1970s. Stitcher's was a supermarket that was on this site for a while. Mr Frost, who came to Rayleigh in 1842, is fondly remembered for the lovely confectioner's and tobacconist's, which retained his name. All the property is still easily recognisable in 2012, as shown in the lower photograph.

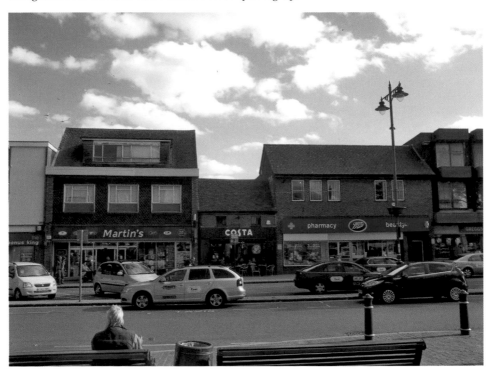

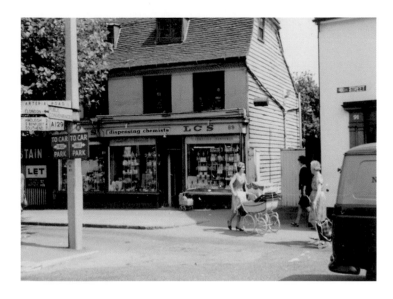

High Street Rayleigh Lanes

Other parts of the High Street have been completely demolished to make way for new developments, some more pleasing to the eye than others. A chemist's shop for over seventy-five years under various names – including Davies, Thurgar and Palmers – the London Co-op is shown here in the upper photograph. It is now a popular indoor market with a variety of different stallholders.

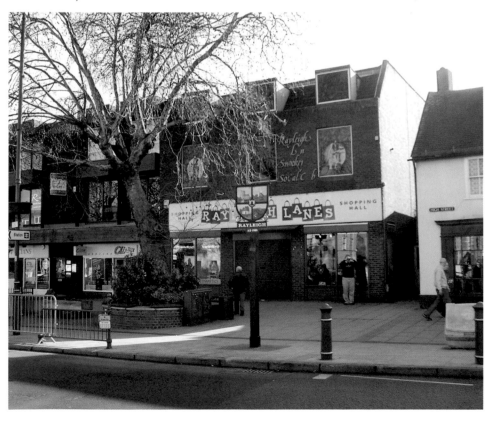

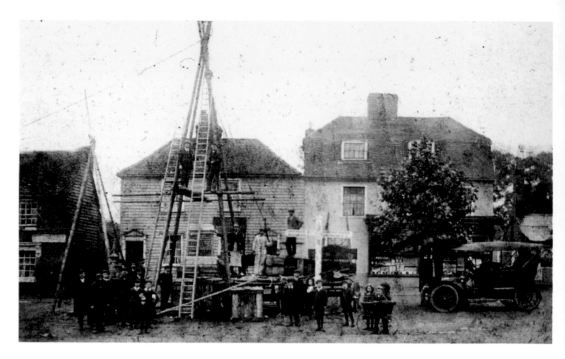

Martyrs' Memorial

In 1555 two local Protestants were burnt at the stake in the High Street for refusing to revoke their religious beliefs and convert to Catholicism. Early in the twentieth century, three local Protestants decided to raise funds for a commemorative plaque. They soon raised £85 and the top picture shows the construction of the memorial in 1908. Note the model 'N' Ford alongside. The lower picture, taken shortly before the First World War, shows three schoolboys patiently waiting so as not to blur the photograph. It also shows the town pump, from which a pail of water was available for ½d in the winter and 1d in the summer in the mid-nineteenth century.

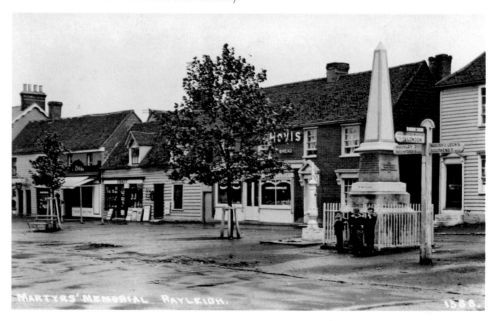

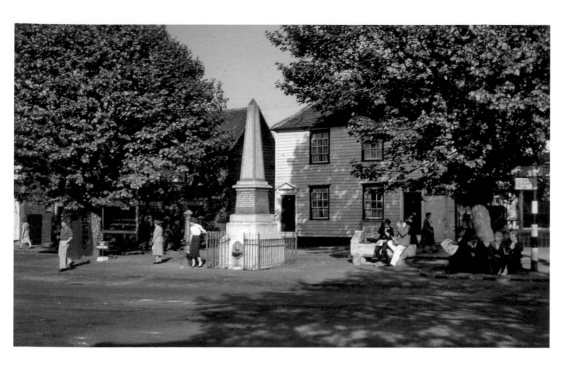

Martyrs' Memorial

The top picture was taken in the early 1960s and shows the Essex weatherboarded property behind, which was soon to be demolished as it was infested with rats. It is clear that little had changed in the preceding fifty years. With the addition of the Metropolitan Cattle Trough Association drinking fountain erected in the early 1920s this area became known as the High Street trio, as seen below. All are Grade II listed structures with English Heritage.

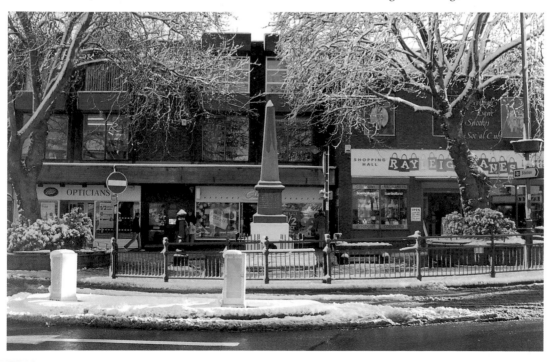

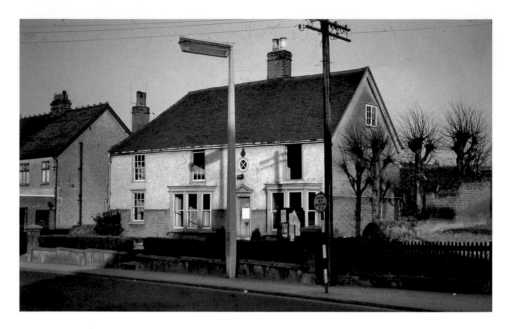

Police Station

Yet another example of the properties once found in the High Street. This building, called Peverills, was the farmhouse for Hog Farm. In 1830 the barn was set on fire and one of the firemen was accused of arson, found guilty and hanged at Chelmsford Gaol. Within a few years it was established that he was probably innocent. Now it is the site of our police station, although earlier police stations were by the junction of the High Street and Eastwood Road and, for a short time in the 1930s, opposite the Weir Hotel on the A127.

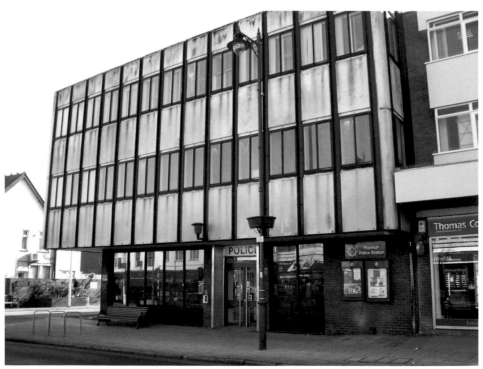

Paul Pry

Over the centuries, Rayleigh has had a large number of coaching hotels, pubs, inns, taverns and ale houses. One of these is the Paul Pry. Although an inn since 1640, it only gained its name in 1825 – from comic actor Paul Pry, who played the lead in a comedy at the Shaftsbury Theatre, London. The pub once had four separate drinking rooms for the gentry, businessmen, agricultural workers and tramps that were sometimes given the slops at the end of the day. Note the changes that have taken place in the eighty years between the dates of these two photographs.

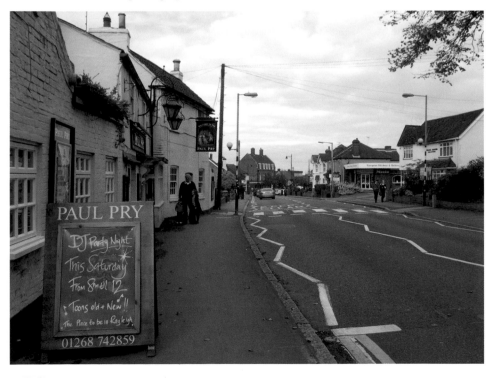

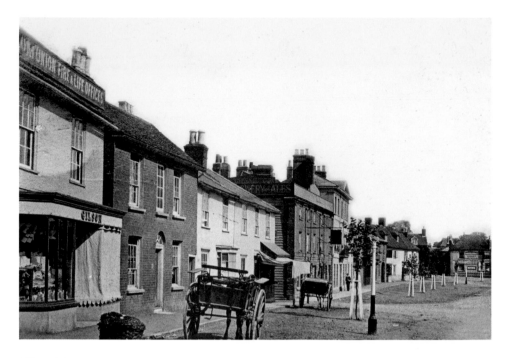

Gilson's Row I

This area of the High Street is known by many as Gilson's Row after the prominent grocer's that traded on this site from the 1730s. The dramatic change in frontage, as seen in the lower photograph, came about in 1927. What a wonderful window display is shown here. Next door can be seen the Premier Hairdressing Saloons, with ladies at the front and gentlemen to the rear.

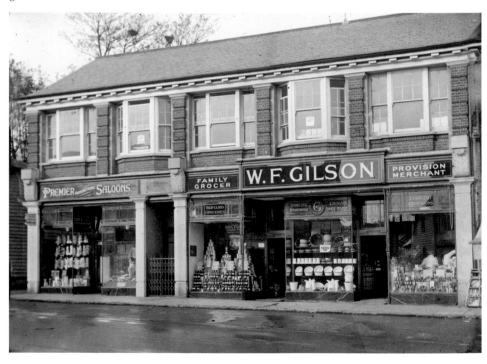

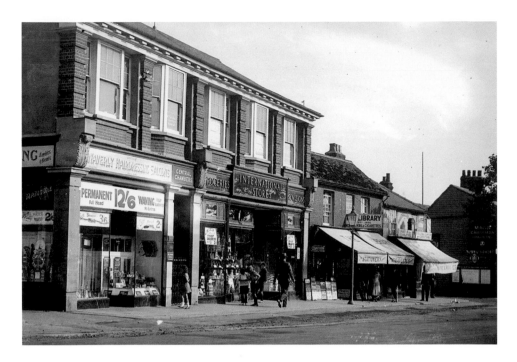

Gilson's Row II

In this slightly later photograph, Gilson's has become the International Stores and the Premier Hairdressing Saloons has become the Waverley Hairdressers. Also seen here is the well-known newspaper, stationery and small gifts shop called the Library, while the gate in the centre leads to the Central Chambers on the first floor, which for many years was the local office for the registration of births, marriages and deaths. By the 1960s, the International Stores has changed to a more modern frontage, and Stevens the Jewellers has replaced the hairdressers. However, the first floor looks exactly as it did forty years previously, and it still does today.

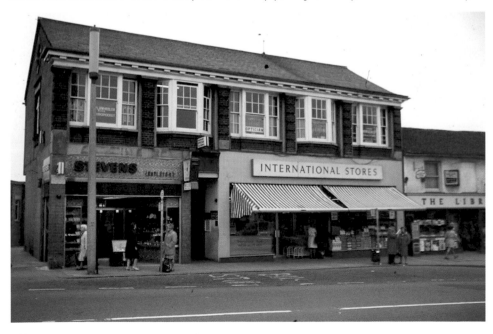

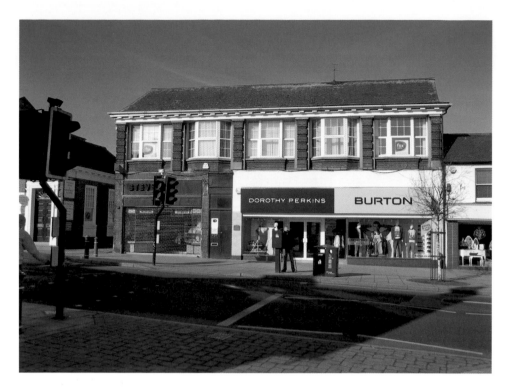

Gilson's Row III

For over forty years Stevens the Jewellers traded on the site of the old hairdresser's, but it closed in 2012 and in its place an 'old-fashioned' sweet shop has opened. Rayleigh has remarkably few empty shops in the High Street, which is commendable bearing in mind the current economic climate.

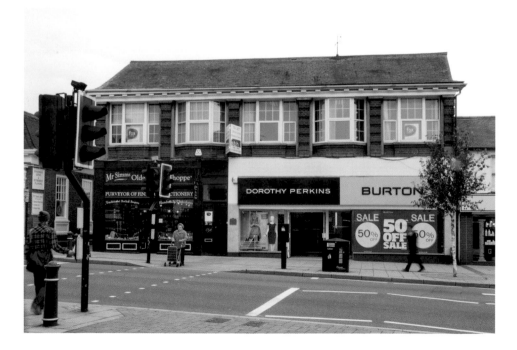

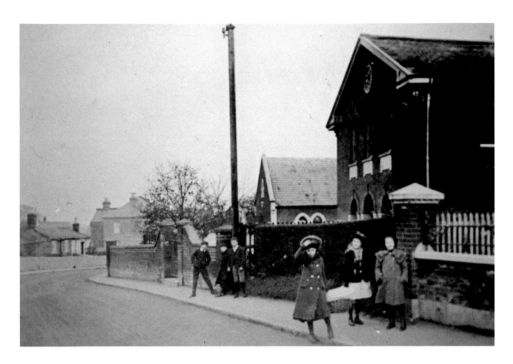

Baptist Church

This is the Baptist church. At this point the High Street becomes the High Road on its way to Rayleigh Weir. It was built in 1798, a year after the Revd James Pilkington came to Rayleigh. His first impression of the town was 'a den of iniquity, full of drunken women in the High Street'. Parishioners congregated outside before services, which caused problems for motorists at the sharp bend (seen in the top photograph), and so the road was straightened and some headstones removed to behind the church.

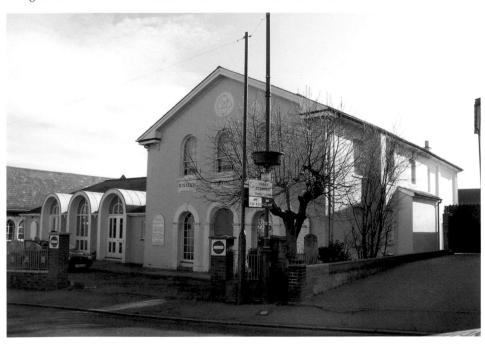

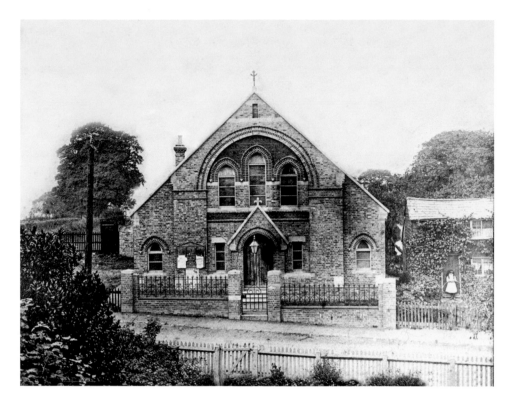

Wesleyan Chapel

This is the Wesleyan Chapel, built in 1884 at the junction of the High Street with Love Lane (originally Glebe Lane). Note the girl in the house to the right, who is playing with a hoop. In the lower picture, the Wesleyan Sunday School appears. It was built in 1902. Opposite, part of the sign for the Elephant and Castle Public House and the entrance to Castle Road (originally Meeting House Lane) are just visible on the right.

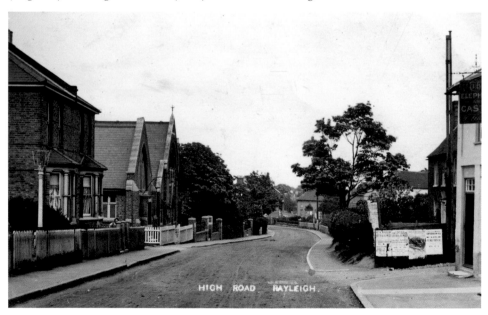

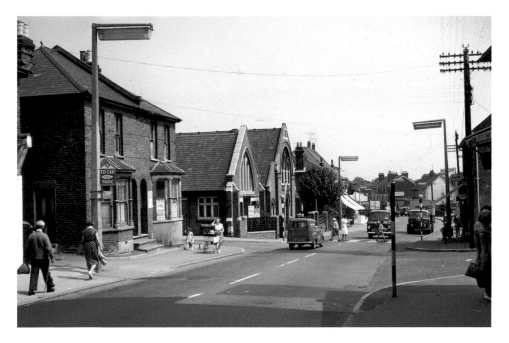

Salvation Army Citadel

A more familiar view, taken in 1963, of what is now the Salvation Army Citadel – the Methodists having moved to their new church in Eastwood Road in 1934. The two residential properties seen on the other side of Love Lane have now been replaced by a retail shop selling bathroom and kitchen tiles, seen below.

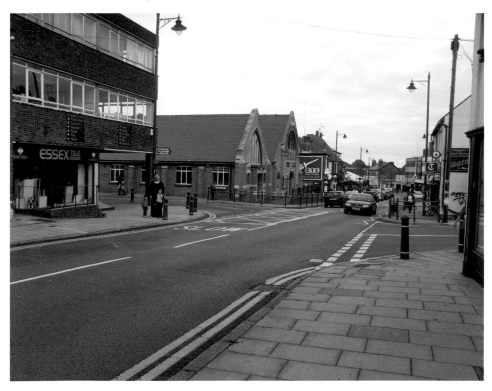

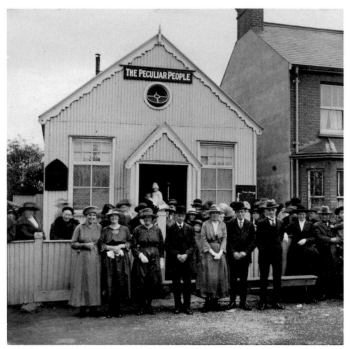

Peculiar People's Chapel and Women's Institue Hall
The first chapel in Rayleigh for local religious group the Peculiar People. The word Peculiar is taken from the Bible and means 'the chosen ones'. Shown here is the wedding of Mr and Mrs McKie, which took place shortly before the Salvation Army moved here in 1923. Now the Women's Institute Hall, it is seen in the lower photograph. Note the heritage plaque by the front door.

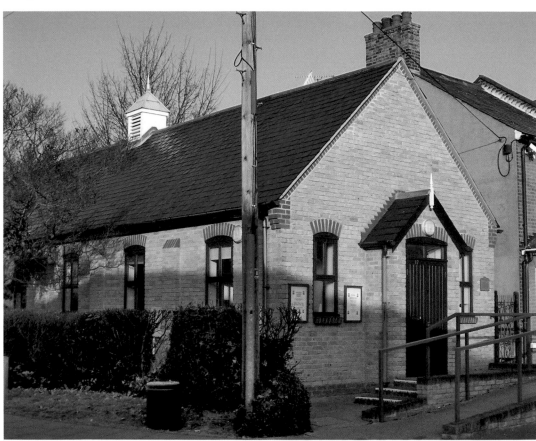

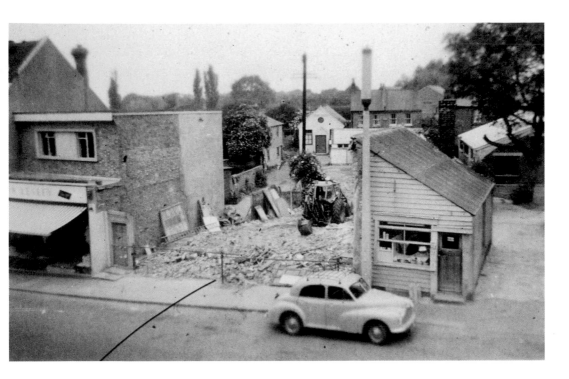

Berry's Arcade

This photograph, taken from the High Street in 1960, shows a view with the WI Hall in the background, before it burnt down in 1989 to be replaced by the current building. The shops were being demolished to make way for Berry's Arcade, seen today in the lower photograph.

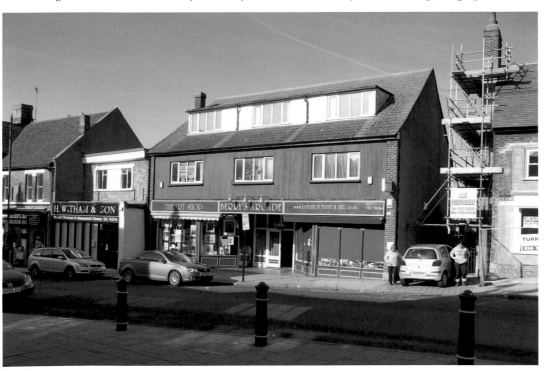

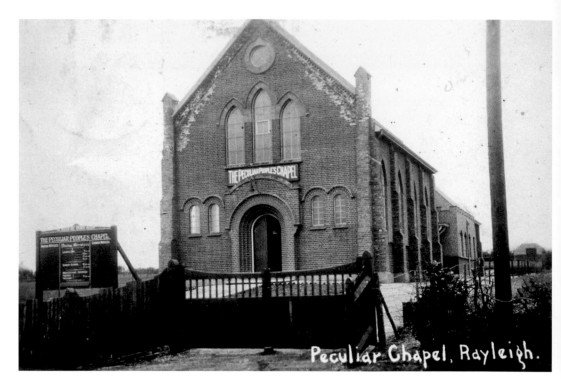

Peculiar Chapel, Rayleigh.

Evangelical Church

When the Peculiar People moved from Bellingham Lane, they came to this site along the Eastwood Road, just past the junction with Stile Lane. Note the later extension to the front. The group changed their name to the Evangelical Church in 1956.

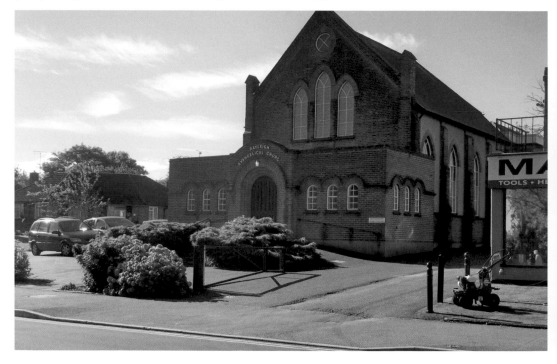

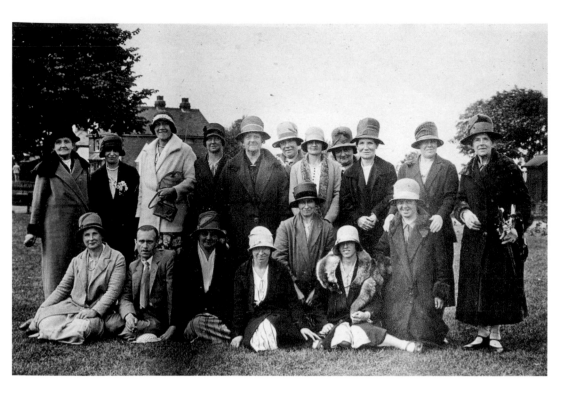

Methodist Church
These ladies with wonderful hats were photographed in 1927; the Methodist Sunday school group was about to take a charabanc trip to Maldon. Perhaps Ernie Lane's father, seen in the front row, was acting as a chaperone, as the group also includes Ernie's mother and aunt (front row, third and fourth from the left). The Methodist church was on Eastwood Road, opposite the two windmills, which were demolished in the late 1880s.

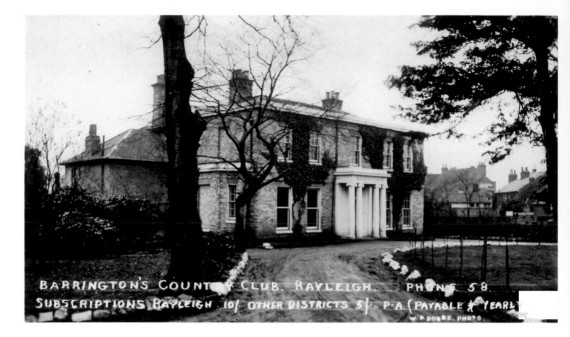

BARRINGTON'S COUNTRY CLUB. RAYLEIGH. PHONE 58.
SUBSCRIPTIONS RAYLEIGH 10/ OTHER DISTRICTS 5/ P·A·(PAYABLE ¾ YEARLY
W. A. DOBBS, PHOTO.

Barrington's

The original property on this site was once home to the keeper of the King's Park. The current property dates from the mid-nineteenth century. For a short while in the 1920s it was a country club, from which ladies were at first excluded. The Billiard Room was in the front room on the right. In 1934, a museum displayed Rayleigh artefacts here. Regrettably, it did not last, due to a lack of volunteers. The building now houses a prominent firm of local solicitors, with the Rochford District Council Chamber to the left.

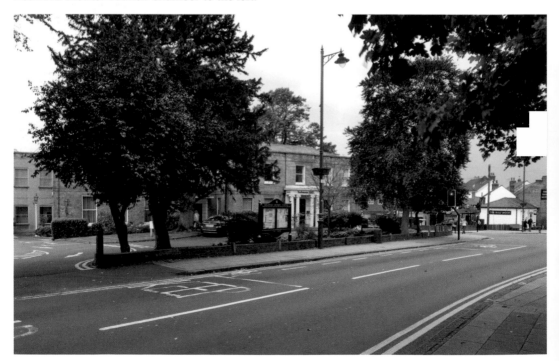

Bull Lane

Shown here in the early 1960s, Bull Lane was once the route of the bull's one-way journey from his field to the Bull public house (Kingsleigh House), where bull baiting took place until the pub closed in 1791. The narrow width of the road reflects those of many around town. However, horses and pedestrians could pass each other with ease. Note the lychgate of the church, built in 1957 by Dowling's, whose shop was just past Kingsleigh House in the High Street.

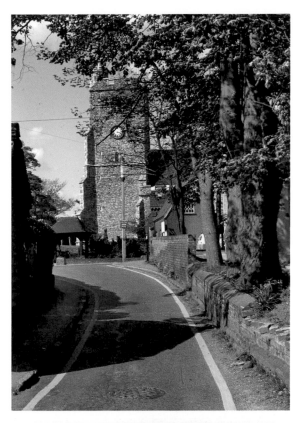

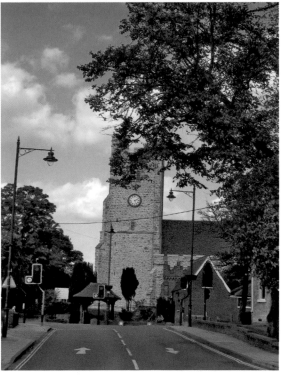

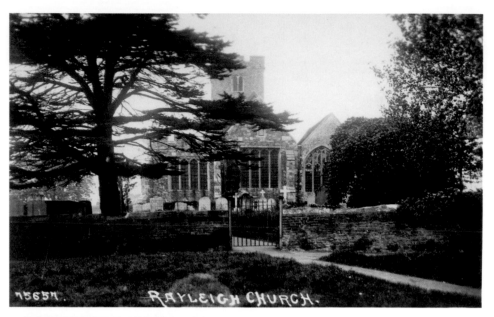

RAYLEIGH CHURCH.

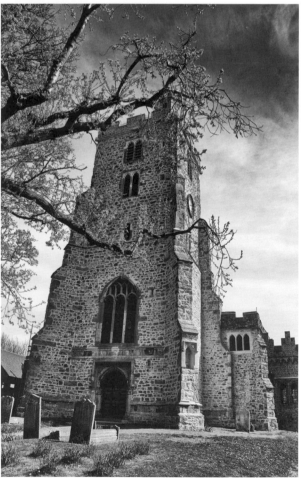

Holy Trinity Church

Our parish church. It has been the site of religious observance for around 1,000 years, although the present building dates mainly from the Perpendicular period, with later additions. In 1846 some Cromwellian armour was found hidden in the loft of the rectory. The photograph below, taken in 2011, demonstrates what a dramatic effect black-and-white photos can achieve.

The Parish Rooms

The church parish rooms, originally built in 1792, but later demolished and rebuilt in 1863, was the first National School for boys. (Girls were schooled at the Baptist Hall.) It was used for a while during the First World War as an entertainment centre for troops billeted in town. Later, it was in danger of collapse, as seen here in 1978, and suffered a fire in 1980, at which time some locals favoured demolition. However, it was saved and has in recent years been the premises of many different restaurants, as seen below in 2012. One group of eleven employees from a previous restaurant became millionaires after a lottery win.

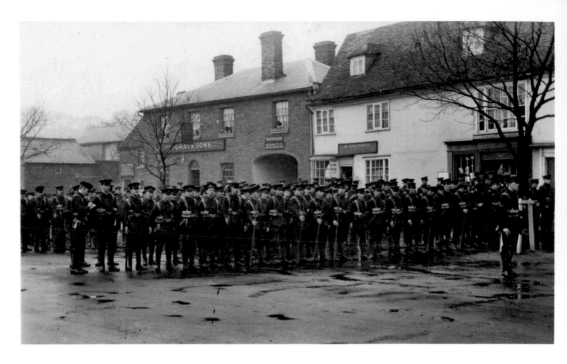

The Kings Royal Rifles Corps in the First World War

This group of soldiers from the King's Royal Rifles 16th (Service) Battalion (Church Lads Brigade), seen parading in the High Street outside the Chequers Pub, undertook part of their training in town between March and May 1915. Most of the men died in the First Battle of the Somme. The same site, now totally different, can be seen below.

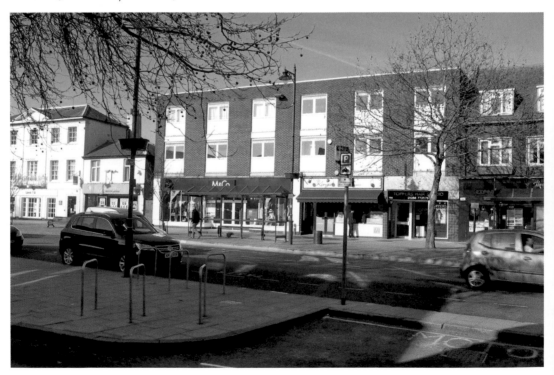

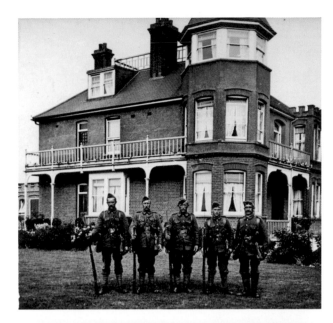

The 18th Middlesex Regiment in the First World War

This group of servicemen from the 18th (Service) Battalion (1st Public Works Pioneers) of the Middlesex Regiment came to Rayleigh in May 1915. Pictured here at one of their billets at Rose Hill in Great Wheatley Road, they landed at Le Havre for the front on 15 November 1915. Rose Hill was home to the well-known Moss family, who were prominent members of the Peculiar People.

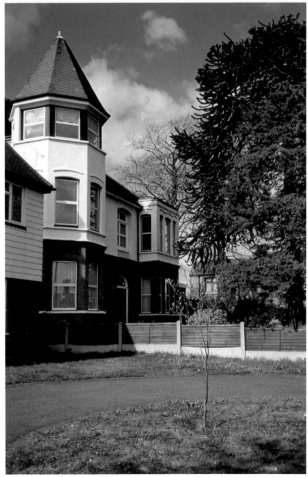

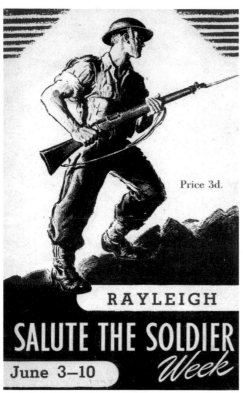

Price 3d.

RAYLEIGH

SALUTE THE SOLDIER *Week*

June 3–10

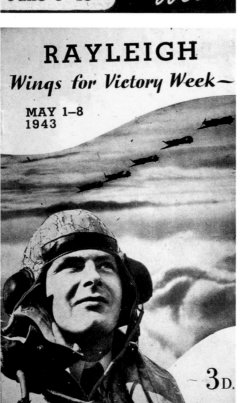

RAYLEIGH

Wings for Victory Week—

MAY 1–8
1943

3D.

The Second World War

Like most towns in the country, Rayleigh residents did their bit to help the war effort. These programmes are but two examples of fundraising events that took place at various venues around town. There was also a shop in town for the Spitfire Fund. A number of properties were damaged during enemy action, and in March 1944 a property in Daws Heath Road was the site of one of the last V2 rockets to fall. Thirteen local civilians died as a direct result of the war in and around the town.

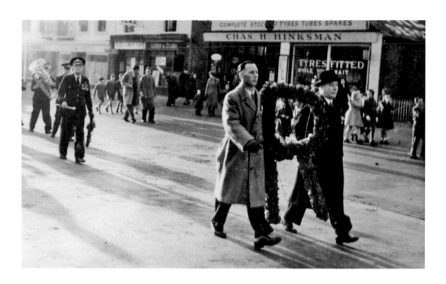

Rayleigh Home Guard

The lower picture shows Mr Jarvis and Mr Game passing Hinksman's garage on Remembrance Sunday in 1948. The top picture shows the 'C' (Rayleigh) company of the 1st Essex Battalion Home Guard in 1944 at their standing down parade, passing Webster's the butchers in the High Street.

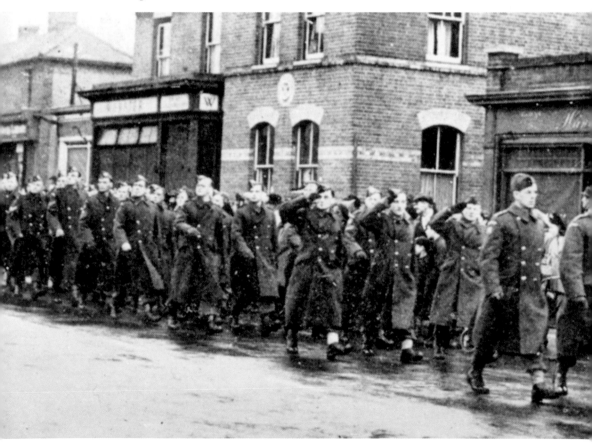

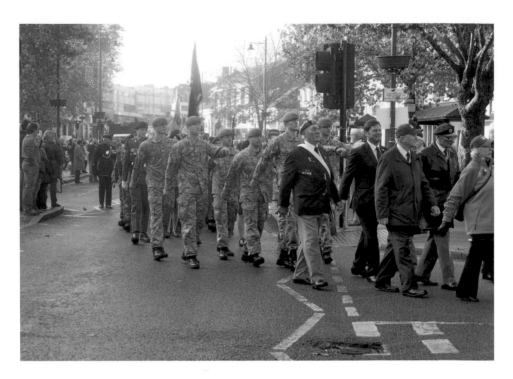

We Will Remember
Every year the town's residents pay tribute to the armed forces in a parade along the High Street on Remembrance Sunday. The podium in Bellingham Lane in 2011 shows, left to right: Captain ?, Simon Smith (Chairman of Rochford District Council) and Mark Francois (MP), with other local dignitaries standing behind, before the service in Holy Trinity.

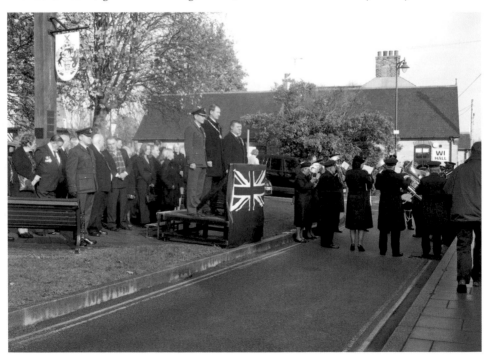

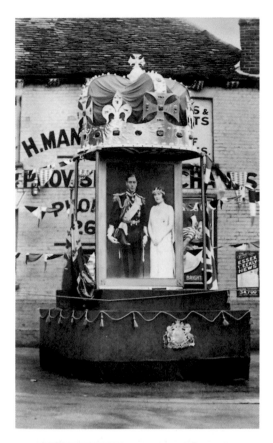

Royal Coronations

Rayleigh residents have always held celebrations to commemorate royal events. Seen here at Mann's corner are coronation 'crowns' for both the 1937 coronation of King George VI and the 1953 coronation of Queen Elizabeth II.

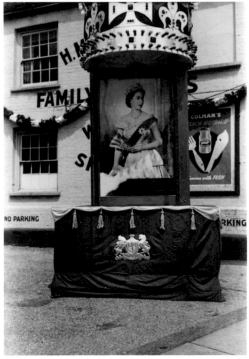

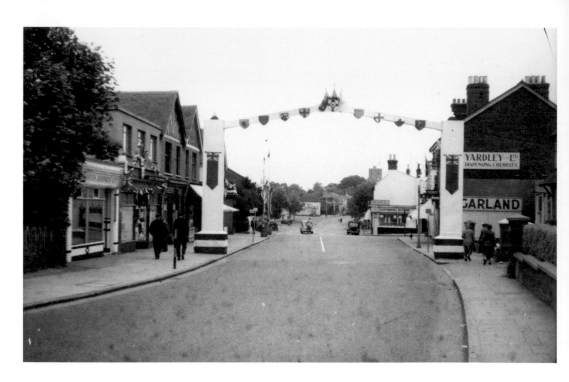

Coronation, 1953 I

The well-known local firm of Dowling's were responsible for providing these arches around town in 1953, as well as other celebratory decorations. The lower picture shows Dowling's hardware shop at the front right.

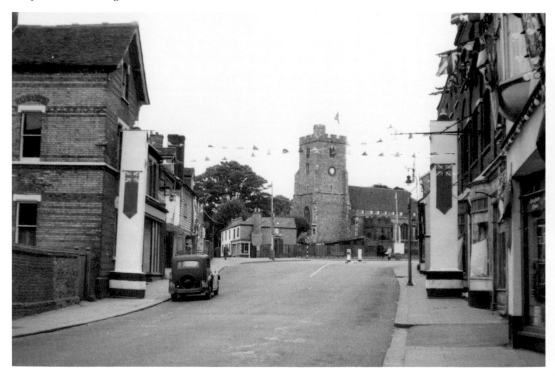

Coronation, 1953 II

Also from 1953, the top picture shows Eastwood Road, near King George's Playing Fields, while in the lower picture there is an advertisement on the weatherboarded side of the Crown for the London & North Eastern Railway.

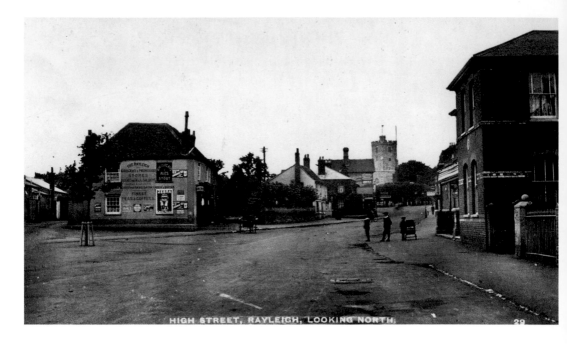

Mann's Corner I

The junction of Bellingham Lane and the High Street is known by many as Mann's Corner, after the grocer's shop that stood on the site for many years. Many local people recall the aroma of freshly ground coffee as you entered the shop. Note the wonderful advertising on the flank wall. Bellingham Lane was originally called Back Lane but was later changed to Bellingham after the well known family who lived in the distinctive house on the opposite corner, shown here in 1963 as a restaurant.

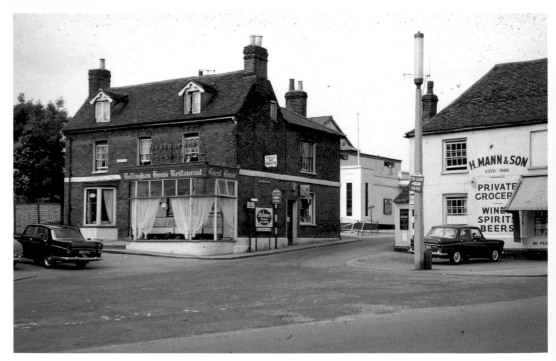

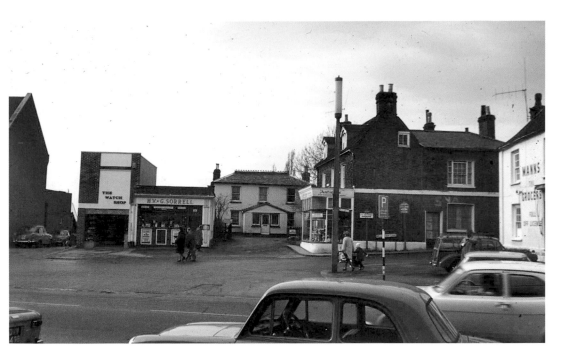

Mann's Corner II

Mr Bellingham was a well-known auctioneer who tried to sell the Tower Mill in 1815. The property was later a private school, antique shop and then a restaurant. The Watch Shop is still with us today, unlike the property set back in the centre of the picture, which was called the Retreat. The Millennium Clock has a time capsule, which was buried in 1999 with twenty-six items inside it. Note the lovely windmill weathervane on top.

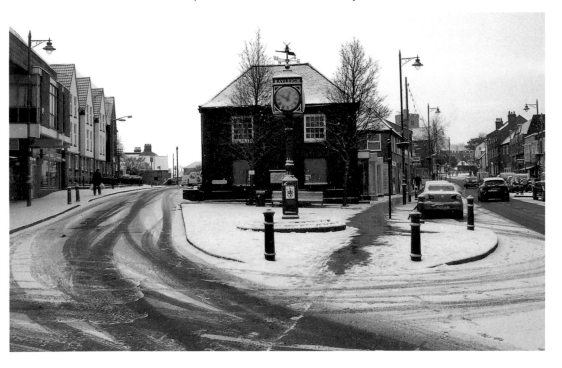

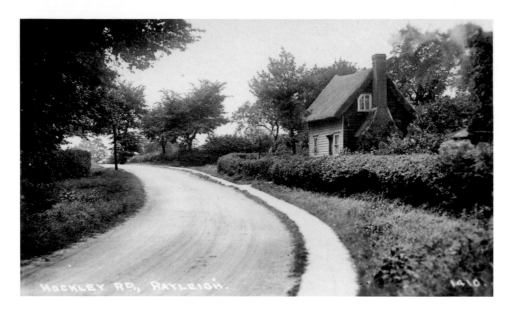

Hockley Road I

This is the Hockley Road, sweeping towards town just past Hambro Hill. Holly Cottage is seen here in 1915. Once a millworkers' area, it also included a substantial home named Wyle Cop. It was dismantled piece by piece when a new housing development was built on the site. Holly Cottage was then rebuilt at Wat Tyler Country Park in Pitsea, as seen in the lower photograph.

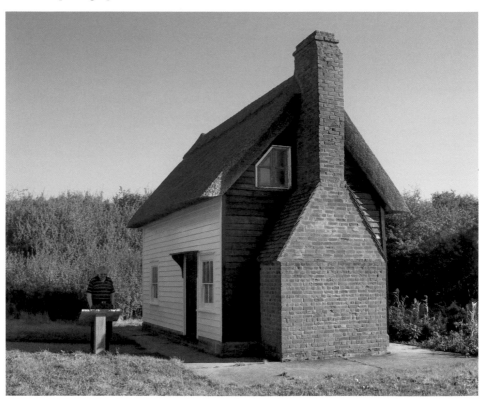

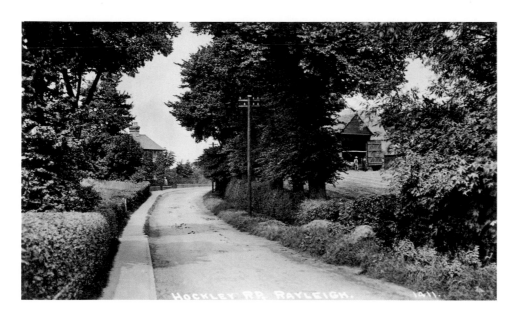

Hockley Road II

This view is taken from the brow of the hill just outside town towards Hockley, showing Lavers Farm on the right. It is now the site of FitzWimarc School, which opened on 19 November 1937. A boy was caned on the first day for sliding down the banisters. A number of sections of Hockley Road were straightened out over the years, and one example can be seen in the lower photograph at the junction with Upway, where a small part of the original road remains in front of the house in the distance.

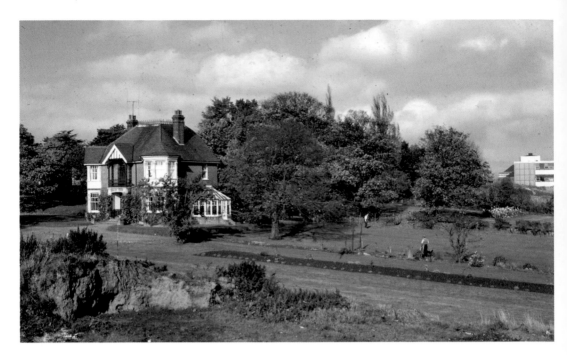

Hockley Road III

Another of the substantial family homes sadly no longer with us. The Rookery, named after the tree at the rear where the rooks nested, was home for many years to the Stratford family, whose garden nursery stretched all the way to Bull Lane. FitzWimarc is visible in the background. The lower picture shows the junction of Hockley Road with Uplands Park Road and Victoria Road, with FitzWimarc on the left. This image can be dated to the early 1960s, as the field, centre right, is now the location of Edward Francis School, which opened in 1966.

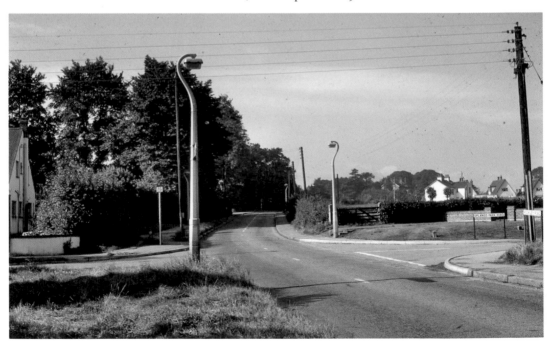

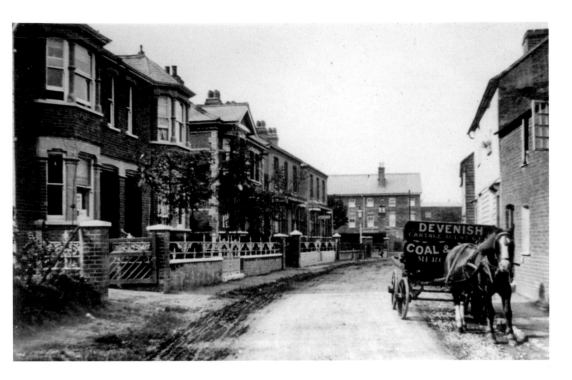

Eastwood Road I

This is the Eastwood Road looking towards the High Street around 1900 from near the junction with Webster's Way, which was built in the 1970s. Look at the cart of Devenish the coal merchant. Members of the Devenish family were for a time licensees of the Crown Hotel, while others farmed Castle Hill Farm, which stretched from the Railway Station to the High Street and Windmill. In the rear centre of both pictures is the back of Dollmartons in the High Street, owned by a Mr Marton, who in retirement sold children's dolls to supplement his income.

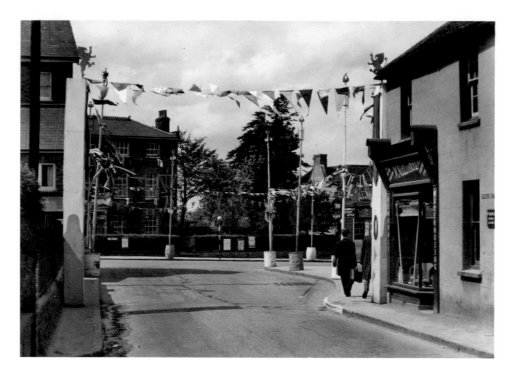

Eastwood Road II

Taken in 1937 as part of the town's coronation celebrations, this view is close to the junction of Eastwood Road with the High Street. The building facing in the High Street is that of Barnards the off-licence, now the site of Superdrug.

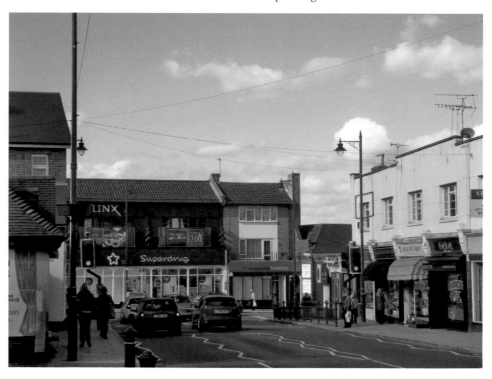

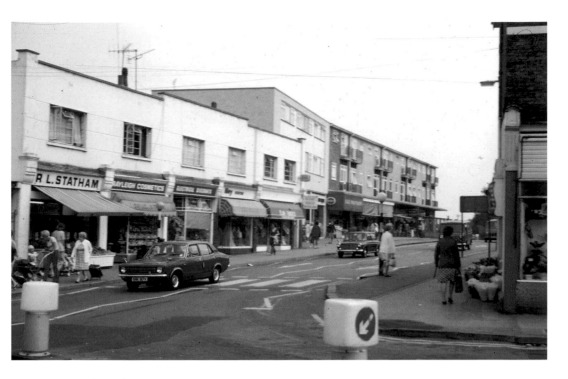

Eastwood Road III

The buildings in the top picture date from the late 1960s, replacing the earlier Sunnyside Cottages. This part of Rayleigh still looks the same today, although the businesses have changed ownership several times.

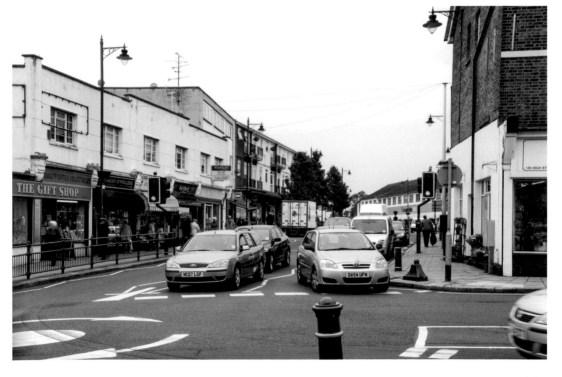

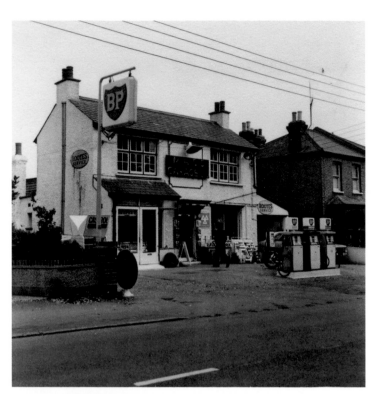

Eastwood Road IV

Further along Eastwood Road and just past the Chase was Macs Garage, shown in the top picture when petrol pumps were much rarer. The garage was the site of a tragic aeroplane accident in 1986. A plane carrying newspapers crashed in to it, to avoid ploughing into residential homes. A commerative plaque, funded by locals, was erected in memory of the pilot, who was killed. Until recently it was the car showroom of Geoff Bray. There are plans for at least part of the site to become a Sainsbury's Local supermarket.

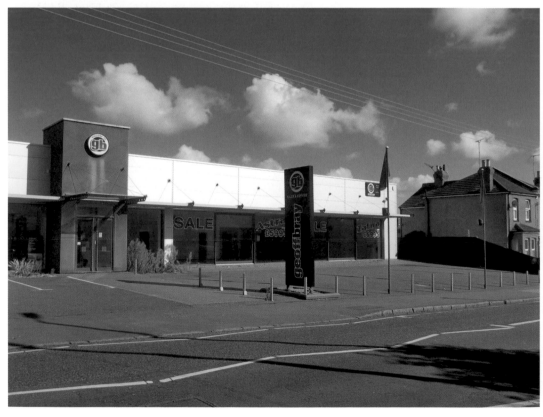

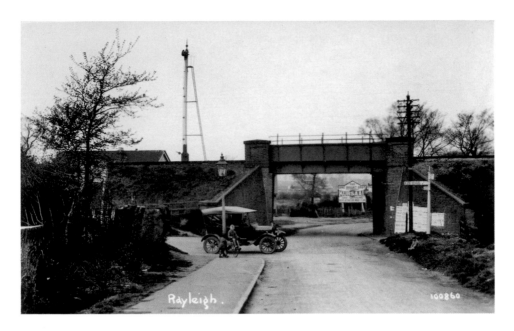

London Hill

Looking down London Hill towards the railway line prior to when the bridge and road underneath were widened in 1936. The young lads are no doubt admiring the lovely old-fashioned 1923 Rover motor car. The directional fingerpost on the right is now on the other corner. Note the advertisement for the Kursaal amusement park at Southend; in the lower photograph the bus stop takes its place.

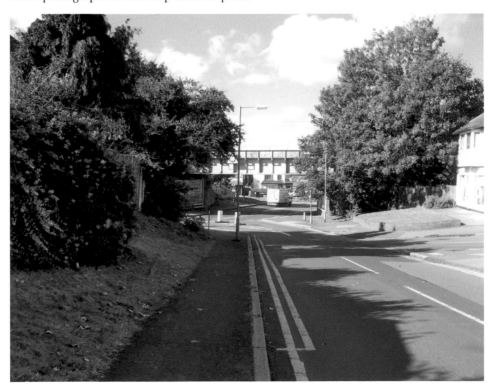

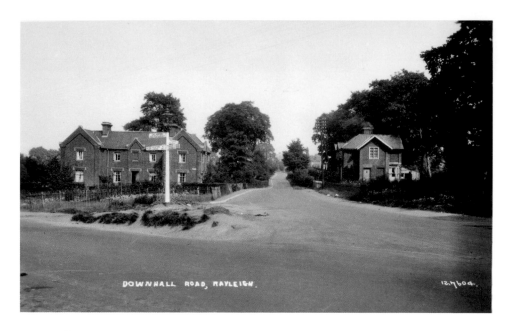

DOWNHALL ROAD, RAYLEIGH. 12.7.1604.

Downhall Road

Just past the railway bridge is Three Want Way, the junction of the London Road with Downhall Road. The cottages to the left were called Louisa Terrace, also known as the Barracks, and for many centuries were the site of the local prison. The area on the opposite side of London Road was known as Hangman's Field or Gallows Mead, after the gallows on the site. These were often located on the approaches to a town as a deterrent to crime. The elephants are on their way back to the site of the circus.

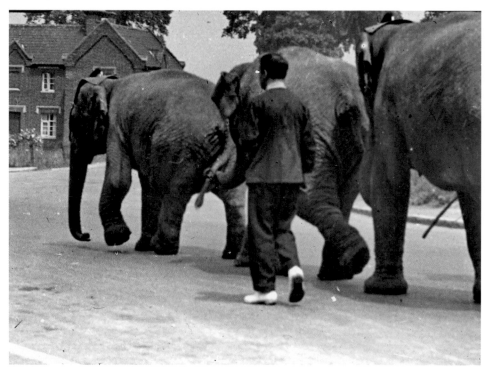

The Travellers Joy

The Travellers Joy public house was built in 1957. In the past it has also been called Piers and the Hungry Horse. The top picture dates from September 1966. Today, as seen below, it is even possible to cast your vote in an election at the same time as having a drink.

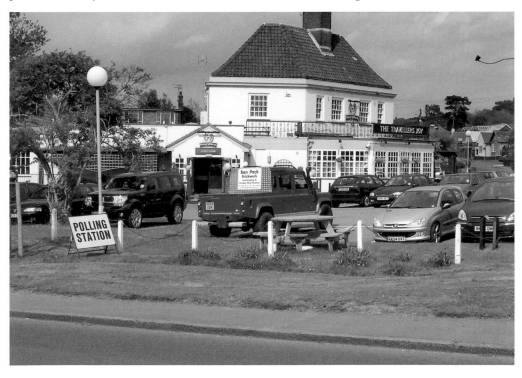

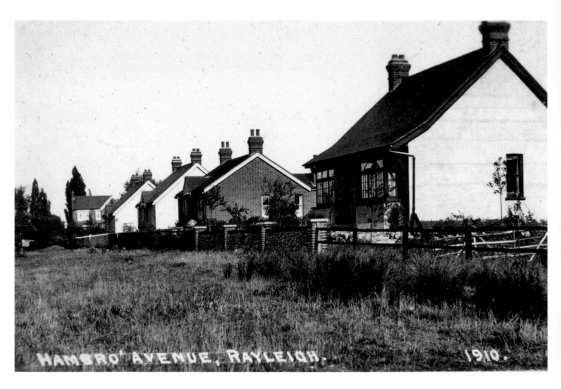

Hambro Avenue
An example of the state of the majority of residential roads in and around town eighty years ago. Things have changed considerably, as can be seen in the lower photograph.

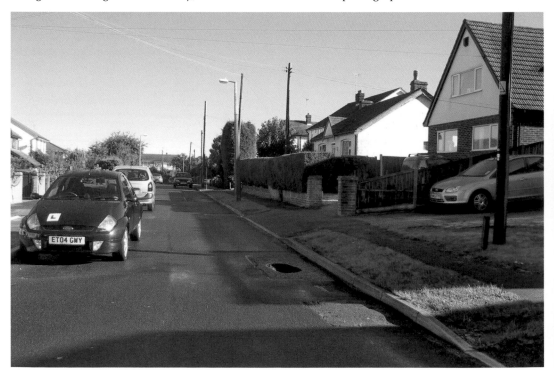

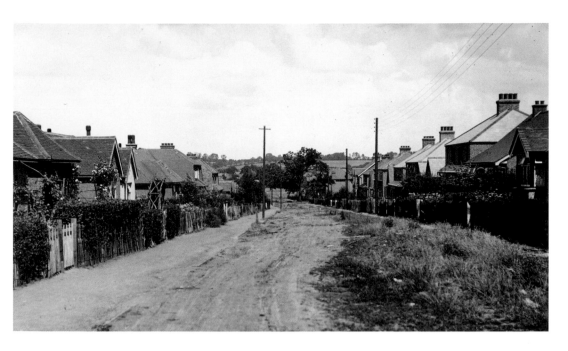

Queen's Road
Another much changed but still easily recognisable residential road, with pavement only on one side, in the 1920s. Pedestrians would need to wear Wellington boots in winter. Compare this with today, where the motor car and the yellow lines now take centre stage.

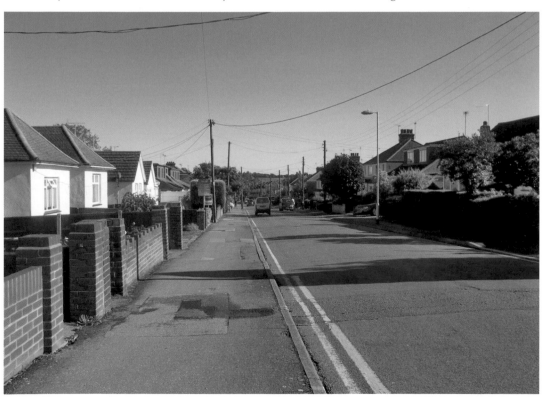

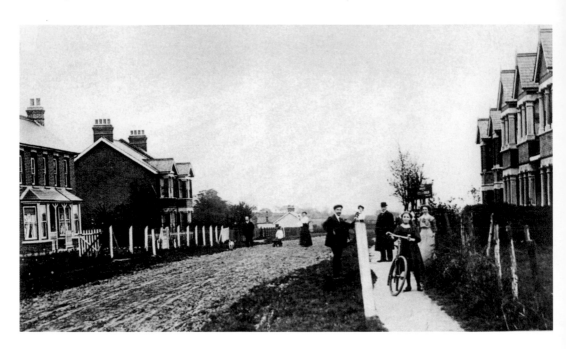

Victoria Road

This is Victoria Road around 1910, before the row of lime trees came and went. Compare the state of the road – compacted earth with grass verges and pavement only on one side – with that of today.

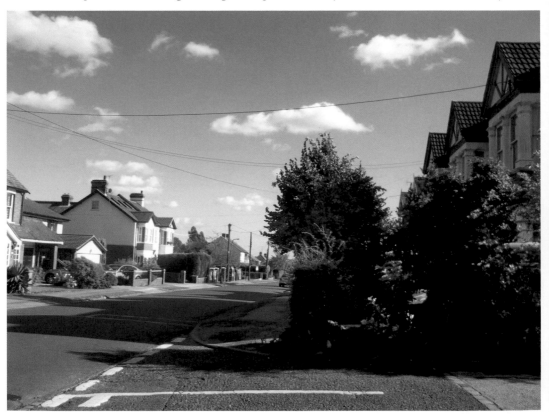

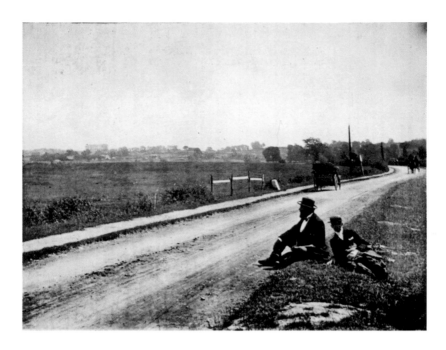

London Road

The London Road looking towards Rayleigh in 1901, part of the Rochford Hundred Adjoining Roads Division of the Essex Turnpikes, from Aldgate in London towards Rochford. A milestone can be seen on the left, just by the fence, where the modern traffic lights are at the junction of Victoria Avenue and Hatfield Road. It is still with us today, showing 33 miles to London and 10 to Southend. The Rayleigh Station estate was soon to be built in this area, and later the Grange Estate.

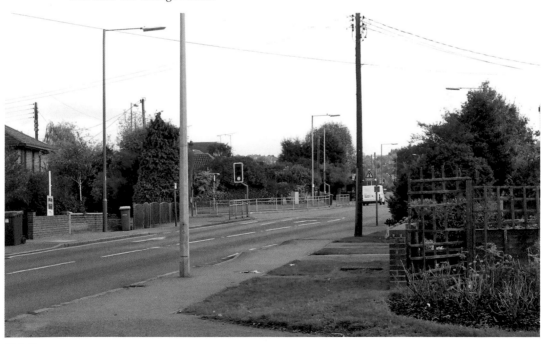

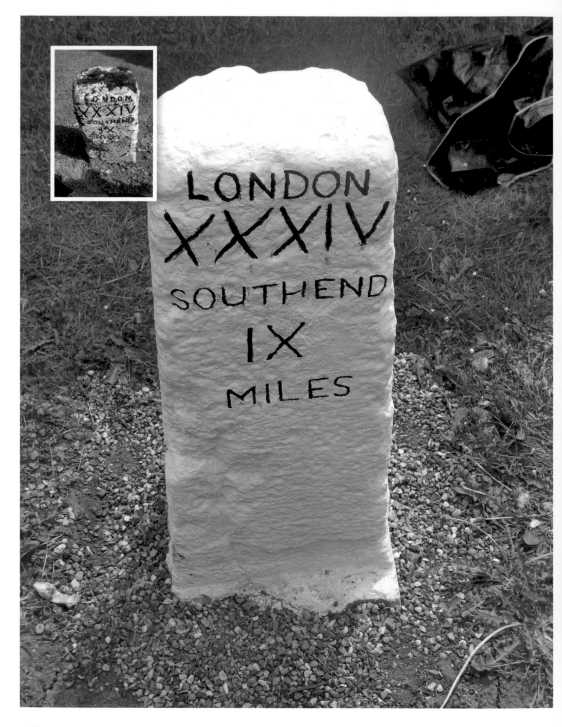

Milestone

The next milestone can be found in the Hockley Road, by what is now Stratford Court. Why this stone has Roman numerals is not known. Author Mike Davies, Terry Joyce and John Nichols, the Essex representative of the Milestone Society, have recently restored this stone, as well as a number of others in the area.

FOOTPATH FROM WHEATLEYS RD. RAYLEIGH.

Great Wheatley

Great Wheatley Farm, mentioned in the *Domesday Survey* of 1086, is at the end of Great Wheatley Road. The site of Kingley Wood is nearby, reached by way of this footpath. Note the ancient wild bluebells in the wood. It was home for many years to one of the earliest Manorial Courts in the country, dating to the fifteenth century. The Lawless or Whispering Court took place once a year at midnight. During the court locals had to swear allegiance to the Lord of the Manor. The court was transferred to Rochford from the seventeenth century until it was disbanded in the late nineteenth century.

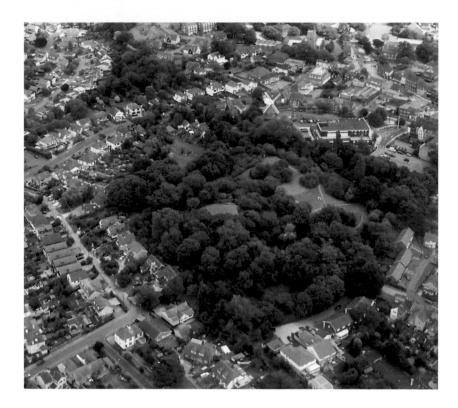

Rayleigh Mount

Another ancient site, this aerial view from 2003 shows Rayleigh Mount, home to Rayleigh's motte and bailey castle. Built soon after 1066 and the only Essex castle mentioned in the *Domesday Survey*, it was finally demolished in 1394 by decree of King Richard I. The lower picture, taken from the Mount, shows Crown Hill with Christ Church, the United Reform church, which was built in 1888 as the Rayleigh Tabernacle, behind the house in the foreground. The Caley Hall, next to the church, was built in 1914.

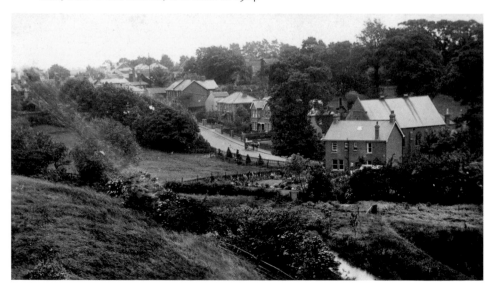

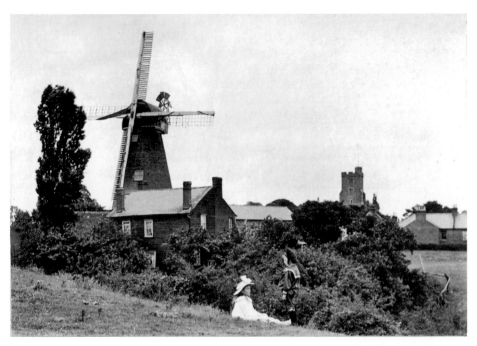

Rayleigh Windmill I

This is Rayleigh Windmill with the tower of Holy Trinity, seen from the Mount shortly before the sails were taken down. The first mention of a windmill in Rayleigh is in 1300, and no doubt there were many others in the area over the centuries. That includes at least one watermill, which was by Whitehouse Farm in the Eastwood Road in the sixteenth century. The lower picture shows how the vegetation has grown dramatically in the 100 years since the sails came down.

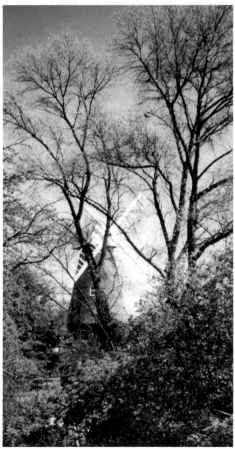

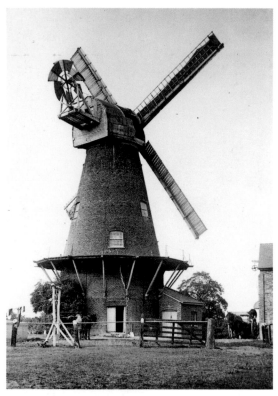

Rayleigh Windmill II

Rayleigh Tower Mill was built in 1809. It has 4-foot-thick walls of local brick, and at 66 feet it is the tallest mill in Essex. The lower picture shows the entrance from London Hill, with the castellated top and the engine room that powered the machinery until milling ceased in the 1940s.

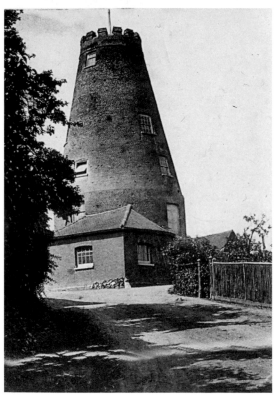

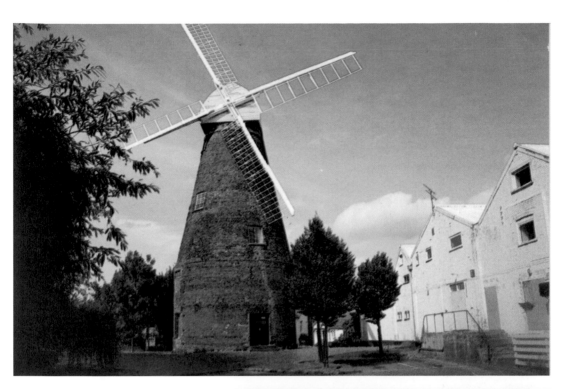

Rayleigh Windmill III

To the right of the mill can be seen the barns used to store the grain until the 1960s. Later, the barns became the Rayleigh Sports & Recreational Club until they were demolished to make way for more car parking spaces. The windmill, seen in the lower photograph in 2012, is registered by Rochford District Council for Civil Ceremonies, and four floors are open to the public from April to September each year, and also to schools and other groups by appointment.

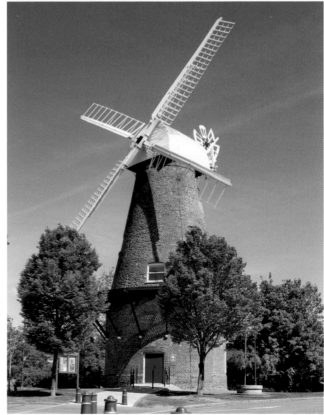

Ruffles

Another one of Rayleigh's windmills, it was owned by the Ruffle family. It was to be found on the brow of the hill along the Hockley Road leaving Rayleigh. Demolished in the 1860s, the house, together with a commorative plaque, is all that remains today. The family were also connected with the two mills along Eastwood Road, demolished in the 1880s. they were located opposite where the Methodist church is today. The upper photograph is an unusual view of the rear of the property, while the lower picture shows a current view of the frontage in Hockley Road.

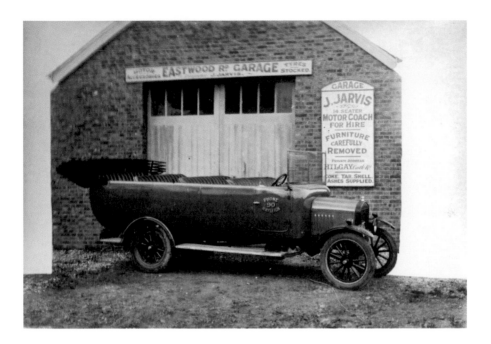

Coach Trip

An early form of transport, this charabanc was operated by the Jarvis family of Eastwood Road. In the late 1920s and the 1930s, many folk enjoyed their first experience of motorised transport when clubs and church groups went on day trips to places such as Maldon and Southend. Members of the Historical Society of Rayleigh are seen here at Walmer Castle in 2010 with a modern coach from the local family firm of Kirby's, which in 2012 celebrated its 60th anniversary of coach travel.

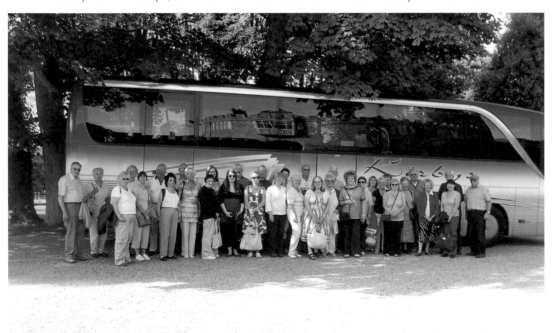

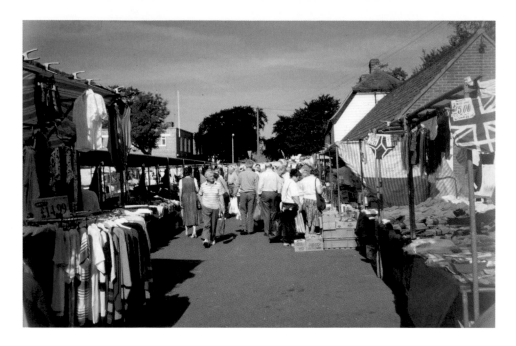

Market

The Royal Charter for Rayleigh's ancient market dates to 1181, one of the earliest in England. The market was originally held on the wide Saxon High Street, later on the Market Square, and in the last century on the car park opposite Holy Trinity. In danger of closure in 2010, it was saved by Rayleigh Town Council and transferred to the Lagoon in the middle of the High Street, as seen in the lower picture. It now has a new lease of life.

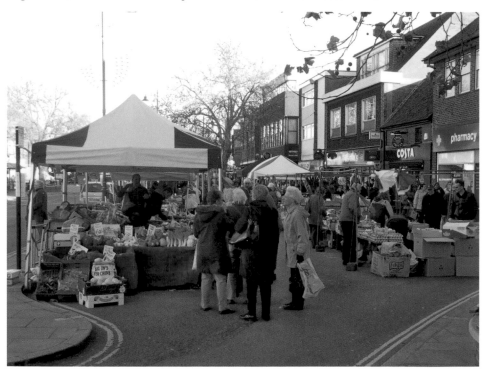

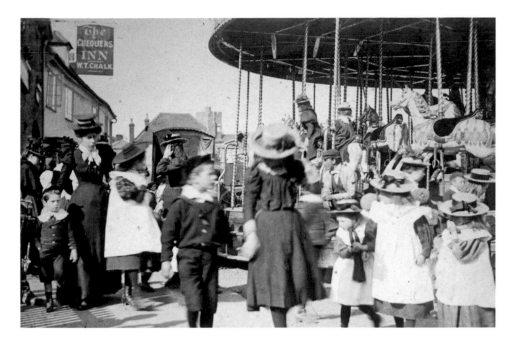

Trinity Fair

The Royal Charter for our town's Trinity Fair dates from 1227. It was held on the Monday and Tuesday after Trinity Sunday each year. The Monday was given over to agricultural buying and selling, while the Tuesday was for merriment. The Trinity Fair was shut down in 1899, as it had become too 'rowdy'. For some it was the only day's holiday of the year. The old picture shows the carousel outside what is now Lloyds Bank, and Mr Chalk, licensee of the Chequers Pub. It was taken in the 1890s, during one of the last fairs. The Horse Fair, which continued until 1906, is shown in the lower picture.

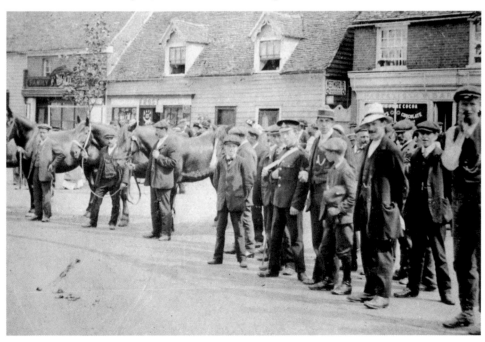

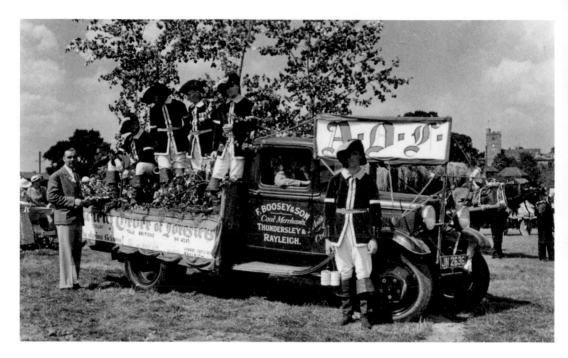

Carnival I

Taking the place of the Trinity Fair, for many years locals and visitors alike enjoyed the annual Carnival. This gathering in Webster's Meadow (now King George's Playing Field) includes the well-known coal merchant Mr Boosey; note the church tower in the background. The lower picture is an example from 1907, showing some of the prizes available for the various competitions held.

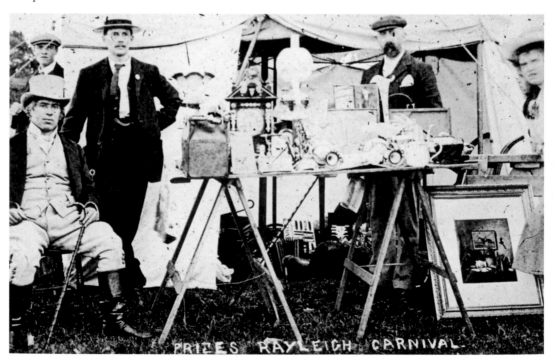

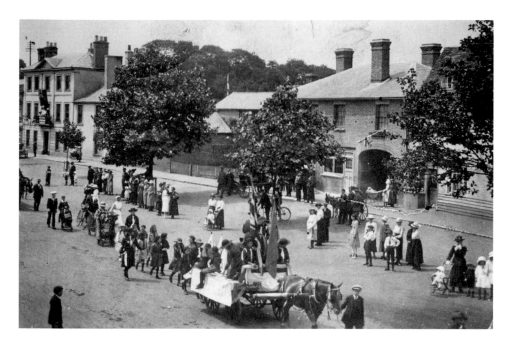

Carnival II

The procession passed along the High Street shown here in the early 1920s, with a view of the archway of the Chequers Pub, leading to its stables and smithy behind. The procession in the lower picture is moving in the other direction. This image shows some familiar High Street traders and dates from the Carnival of 1957 – the last to be held, as it was becoming too large an event for the organisers to arrange.

Town Show

The Carnival was replaced in the 1960s by town shows and this tradition continues to this day, with school fêtes, church fêtes, and the very successful Family Fun Day, organised each year by the local Chamber of Trade and held on the August bank holiday Monday in King George's Playing Field. The top picture, taken in the 1970s, shows that the events had even expanded along Bellingham Lane. The same view today, showing the Windmill, is seen in the lower photograph.

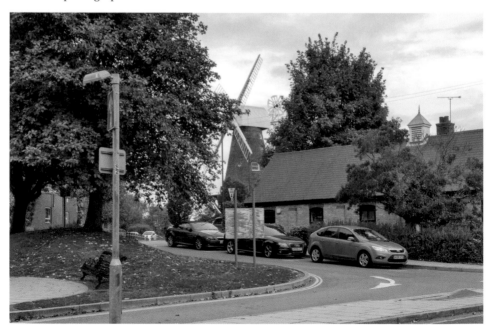

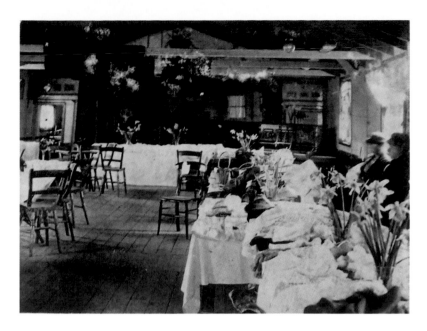

The Clissold Hall

In the age before televisions, computers and mobile phones, locals had to provide their own entertainment. It was to be found in such places as the Crown Hall and the Clissold Hall. The Clissold Hall, the interior of which is shown here, was located in Eastwood Road just by Picton House, near the site of Picton Close today. Local entertainers included Bart Tregenza in a duo with his brother (The Bros Tregenza) and a Pierrot group called the Rayleigh Minstrels. The same site today can be seen in the lower picture.

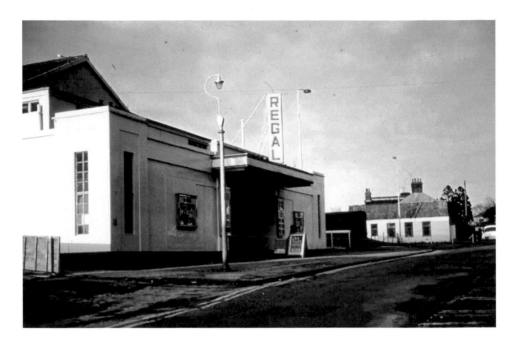

The Regal Cinema I

Our first permanent cinema was the Rayleigh Cinema, behind Bellingham House in what was previously the school gymnasium and sports hall. Opened in the 1920s by Bert Thomas and Ernest Clayton its name was changed in 1931, becoming the Cosy Talkie Theatre. It was demolished in 1936 and replaced on the same site by the 696-seat Regal Cinema, shown in the upper photograph. Sitting alone in the auditorium in the lower photograph can be seen Ron Stewart (known as Regal Ron/Uncle Ron), who rose from tea boy in 1945 to become General Manager. The superimposed image on the screen shows Ernie Lane promoting one of his local history books.

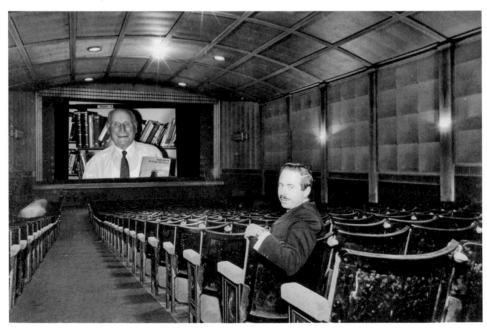

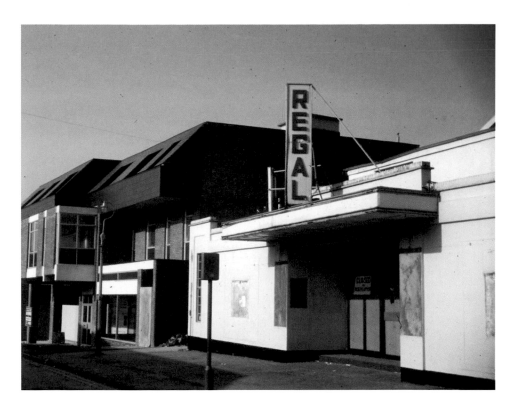

The Regal Cinema II

Sadly the cinema closed in 1973. In its place, Homeregal House opened in 1987, marketed as a 'home for the active elderly'. The site is instantly recognisable from the lower picture. On the wall near the front entrance of Homeregal House is another of the town's heritage plaques.

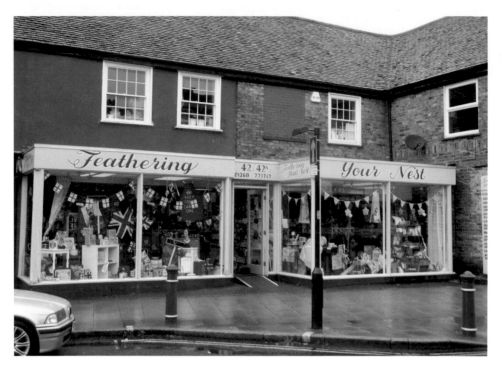

The Queen's Diamond Jubilee, 2012

Rayleigh has a long tradition of celebrating royal occasions, over many centuries, and the Queen's Diamond Jubilee in 2012 was no exception. Many shops and businesses made a super effort and here are two such examples, Feathering Your Nest by the Millennium Clock and Stephen's florist at the junction of the High Street with Eastwood Road.

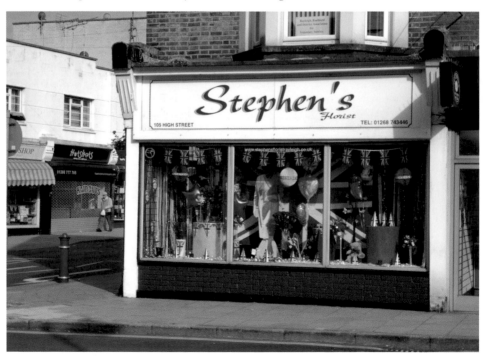

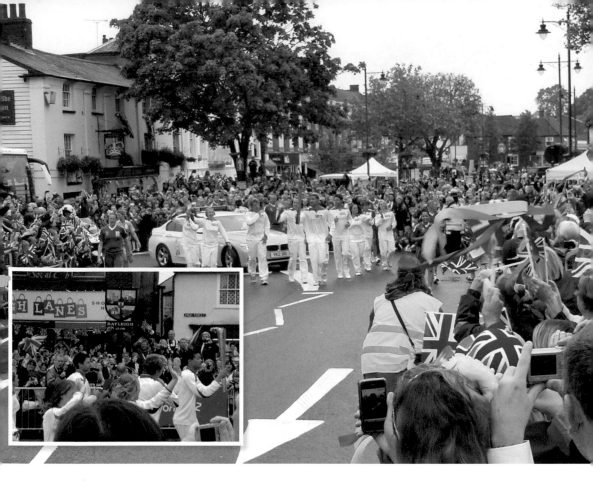

The Olympic Torch, 2012

The largest gathering of folk in the town's history was undoubtedly on 6 July 2012 when the Olympic torch paraded through town, watched by an estimated 30,000 people – a once-in-a-lifetime occasion. One group of torchbearers, seen here, came from FitzWimarc School. At the top of Crown Hill the torch is seen passing the VIP podium with, from left to right, the chairman of Rochford District Council, councillor Joan Mockford, the chairman of Rayleigh Town Council, councillor Robin Dray, our local MP Mark Francois, and the chief organiser of the Olympics in Essex, councillor Stephen Castle of Essex County Council.

Acknowledgements

The above painting is by Robin Pinnock and was photographed by Ian Ward of www.wellmanphotography.co.uk

Our thanks to the following for permission to reproduce the photographs in this book: The Historical Society of Rayleigh: p. 17(top), 59(t), 68(t), 91(t); Ian Ward: Dedication page, 16(bottom), 21(b), 24(b), 25(b), 27(b), 30(b), 42(b), 50(b), 52(b), 53(b), 67(b), 69(b), 90(b); Norman Baur and Eric Mills: p. 18(b), 30(t), 33(b), 34(t), 41(b), 45(t), 51(t), 59(b), 60(t & b), 61(t), 62(b), 63(t), 66(t & b), 72(b), 73(t) and 90(t); Alan Davison: p. 81(b); The Flack Archives: p. 24(t); Frank Harrison: page 13(t), 19(t), 20(b), 36(b), 39(t), 50(t), 52(t), 53(t), 64(t), 65(t), 71(t), 72(t), 80(b); Chris Jones: p. 31(b), 35(b), 38(b), 43(b), 46(b), 79(t) and 94(b); Terry Joyce: p. 19(b), back cover bottom; Ron McEwen: p. 93(t); Deborah Mercer: p. 95(b); Trevor Rand: p. 32(t & b), page 57(b), 82(t), 83(b), 85(t), 87(b); Geoff Sandford: page 37(t) and 38(t); Simmons Aerofilms: p. 10(t); Lesley Sperring: p. 69(t); Chris Taylor: p. 92(b); Walter Voss (Brian Byford): p. 21(t), 29(t), 40(t & b), 44(t), 79(b), back cover top; Spencer Welsh: p. 49(b).

All other photographs were taken by the authors or have been donated to Ernie Lane, Mick Ball or Rayleigh Through the Looking Glass as part of Rayleigh's photographic archives. We have made every endeavour to credit the origins of the photographs used and apologise for any oversight.

Mike and Sharon Davies will donate all the profits they receive from the sale of this book to Rayleigh Through the Looking Glass. Further details of Rayleigh Through the Looking Glass can be found at www.rayleighhistory.co.uk.

We would also like to express our thanks Ron McEwen and Spencer Welsh for their technical help and to Lauren Newby at Amberley Publishing for her help and guidance in the production of this book.